PATTI SMITH 1969-1976
PHOTOGRAPHS BY JUDY LINN

AFTERWORD BY PATTI SMITH

ABRAMS IMAGE
NEW YORK

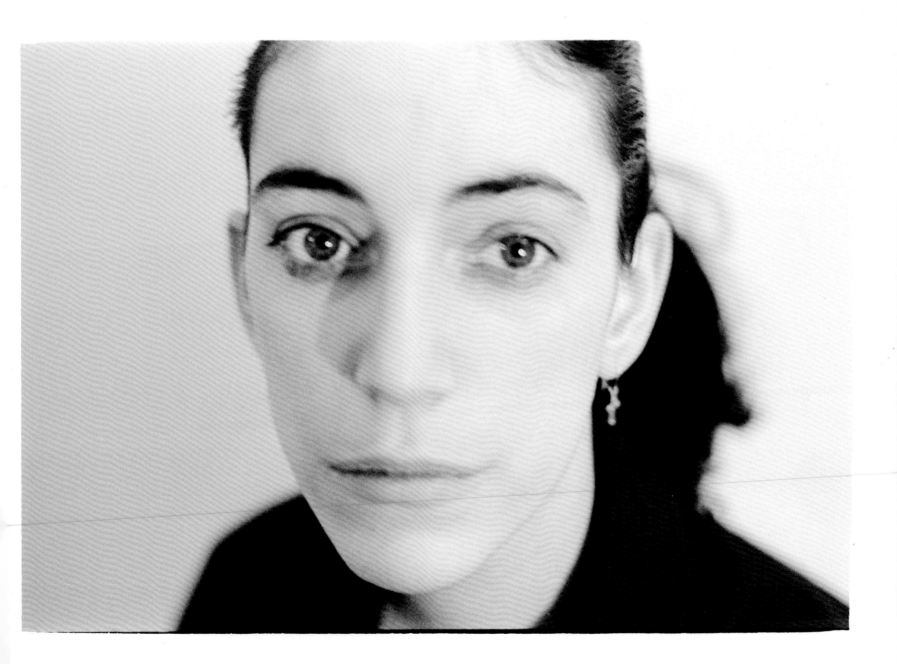

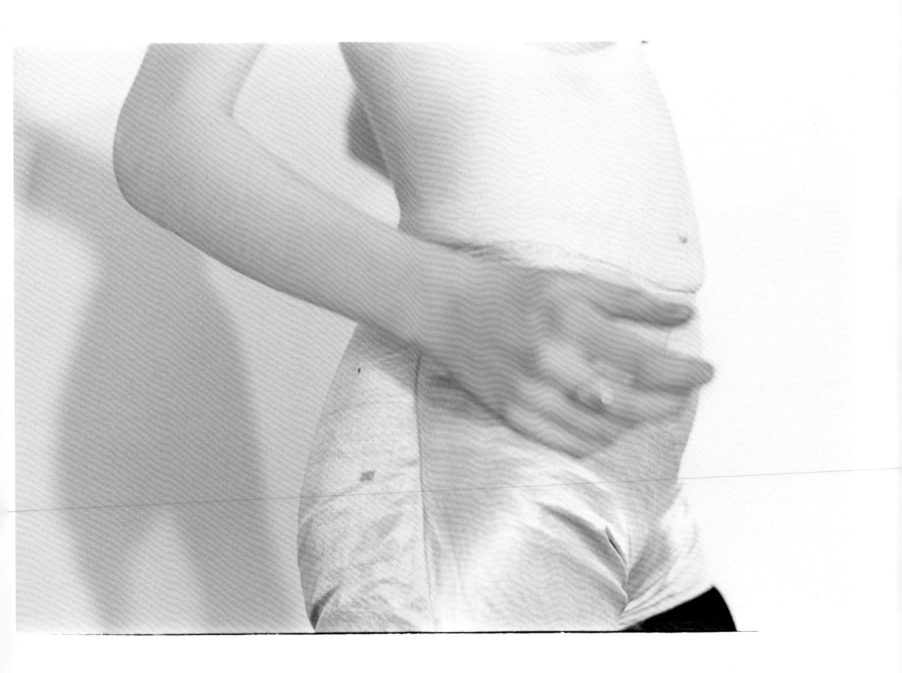

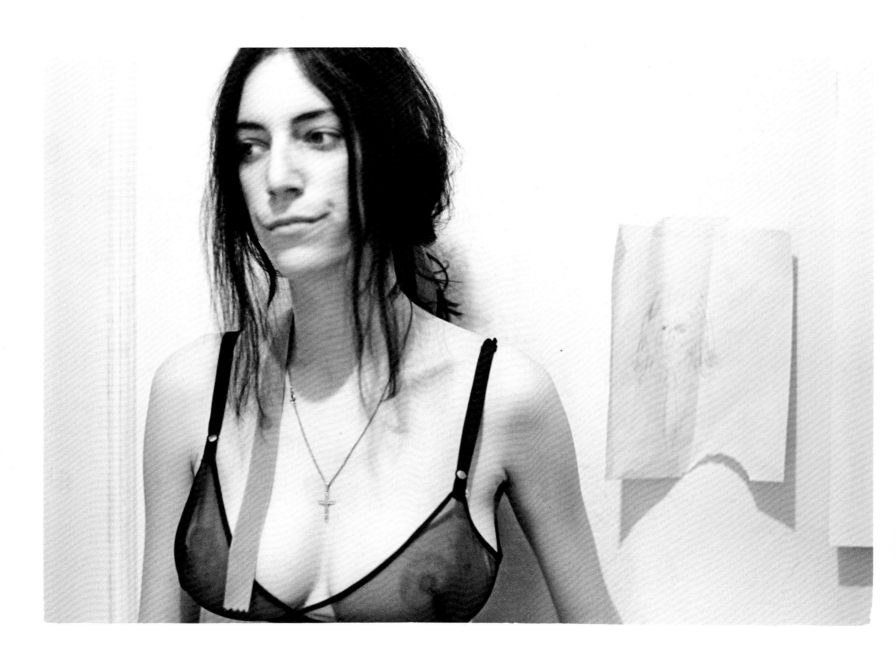

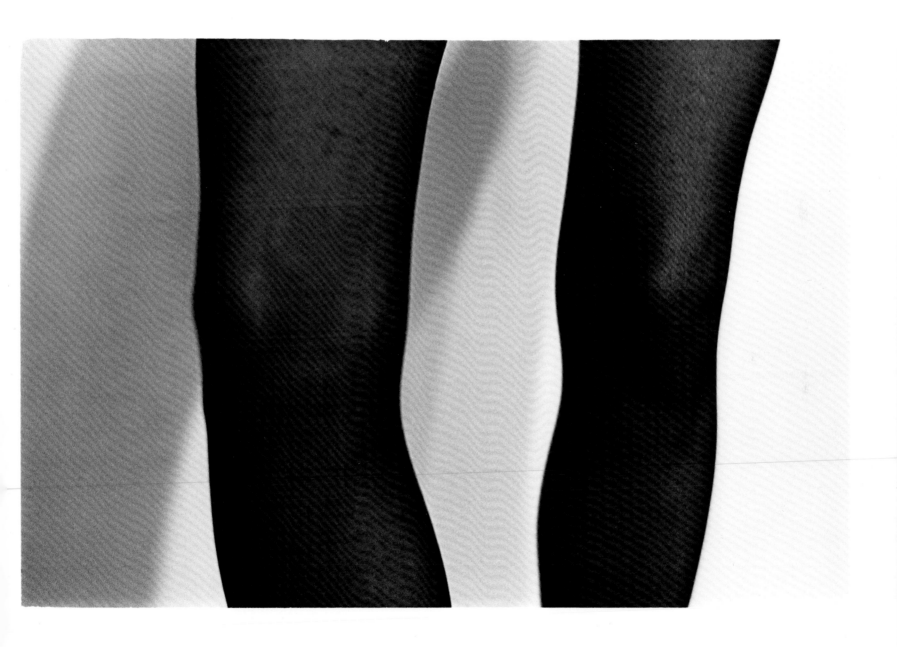

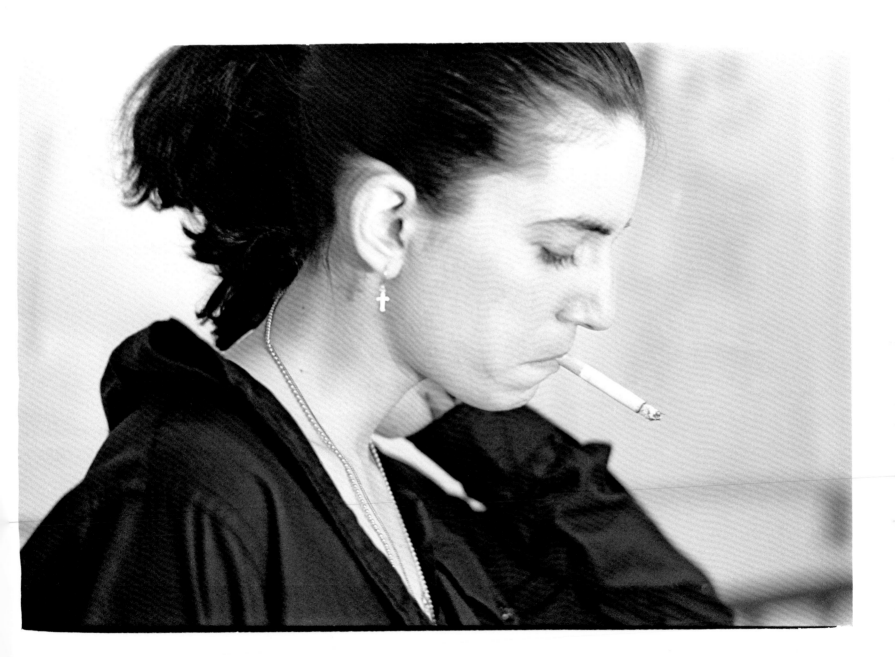

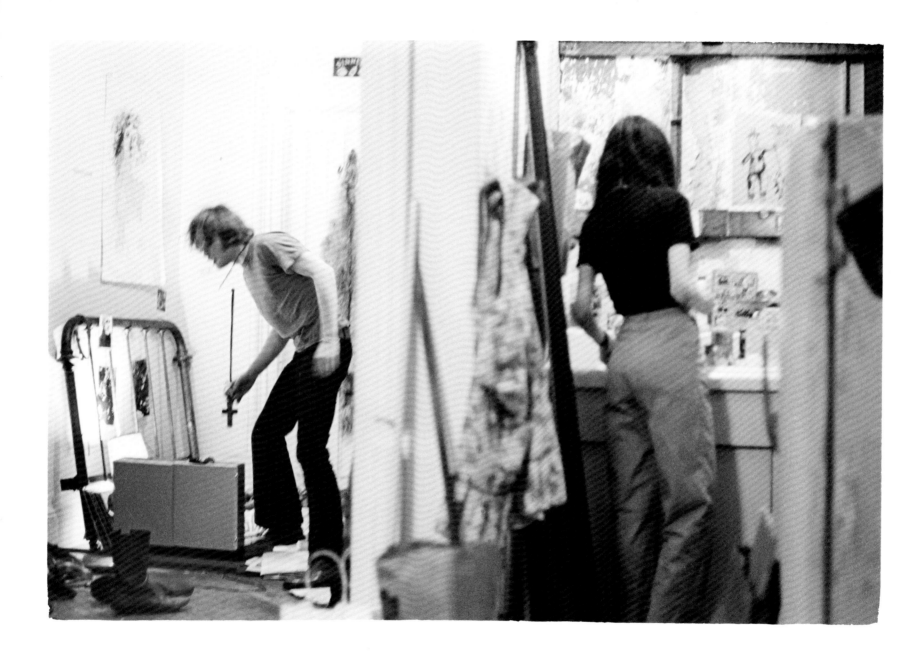

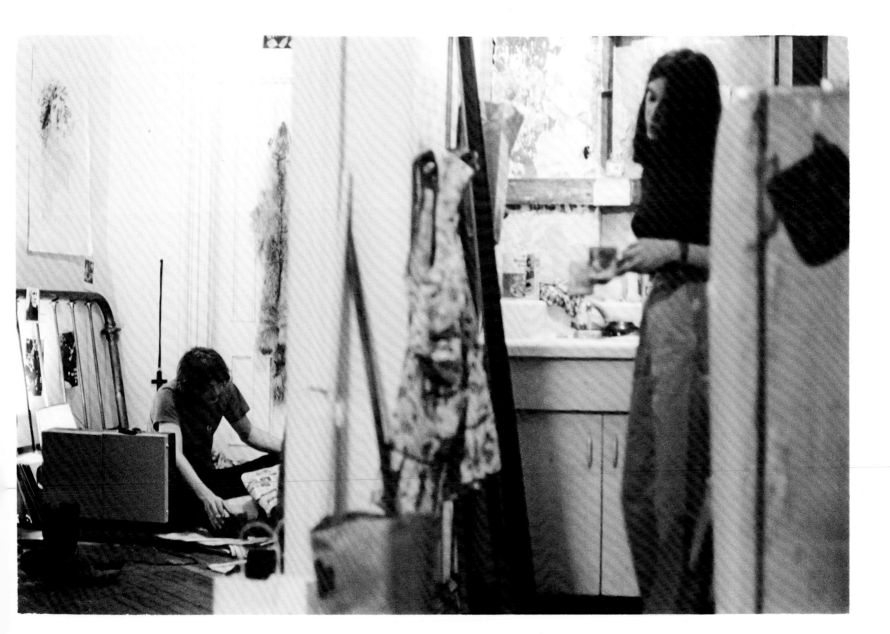

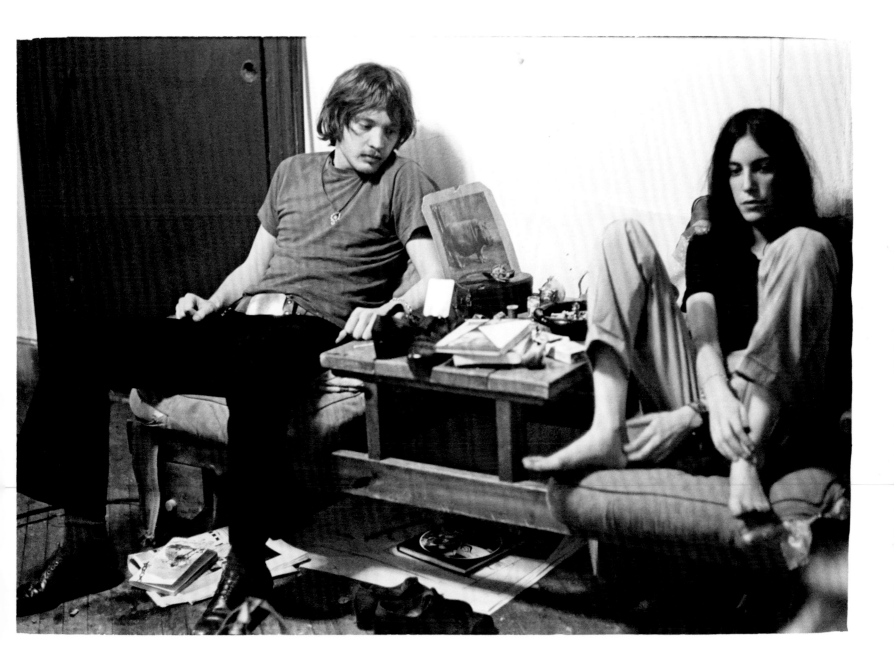

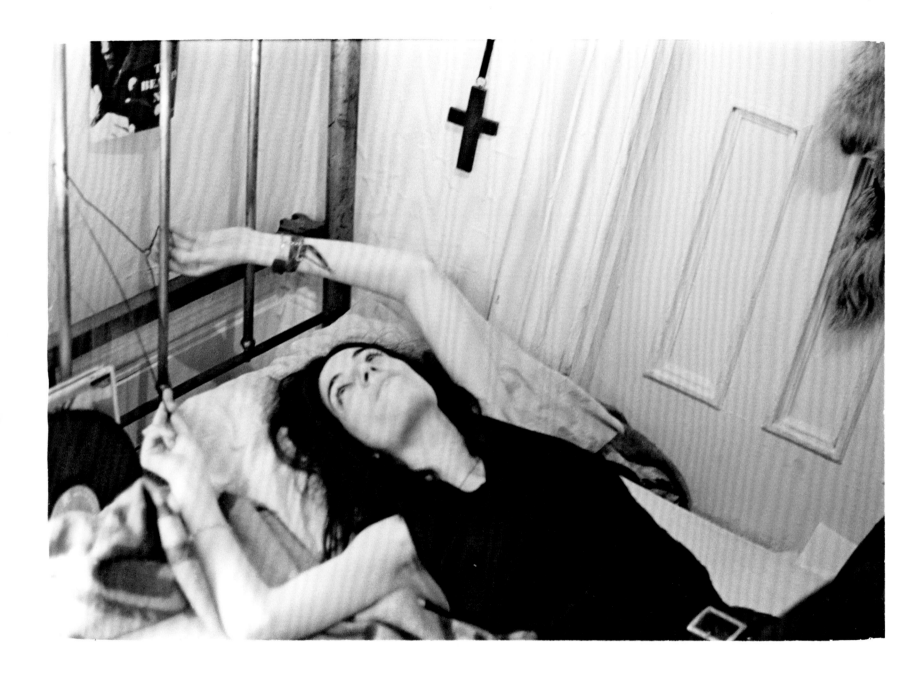

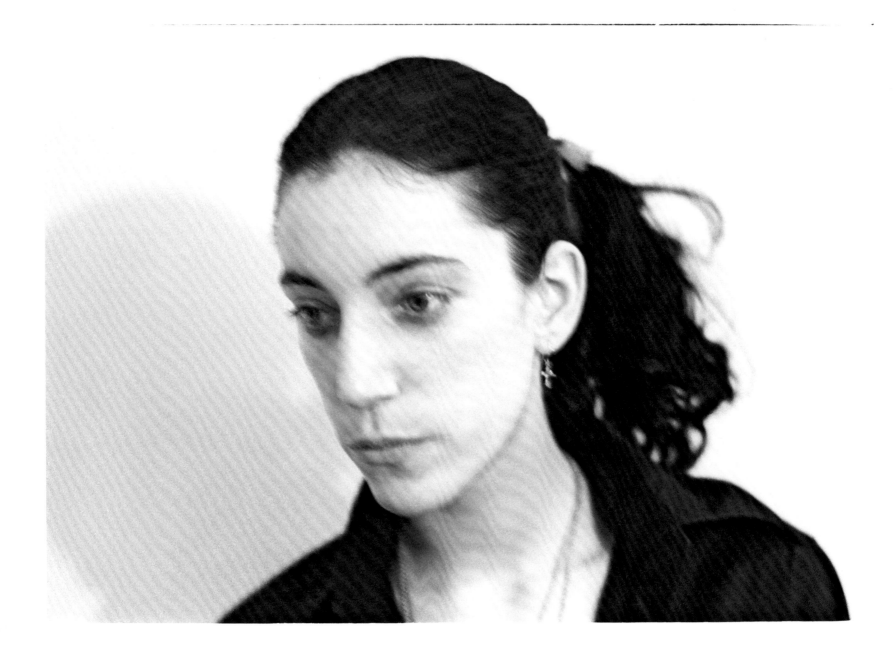

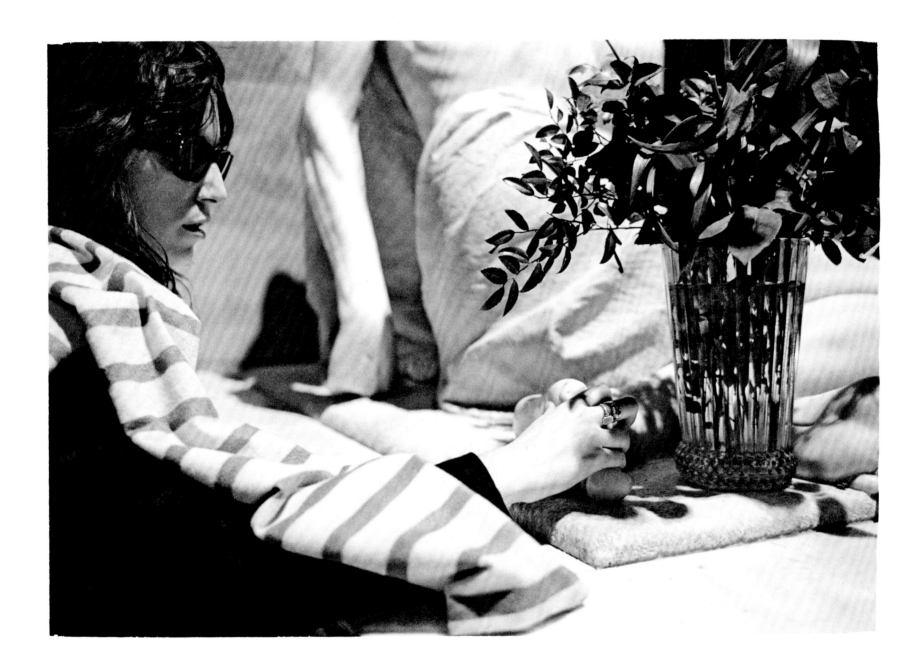

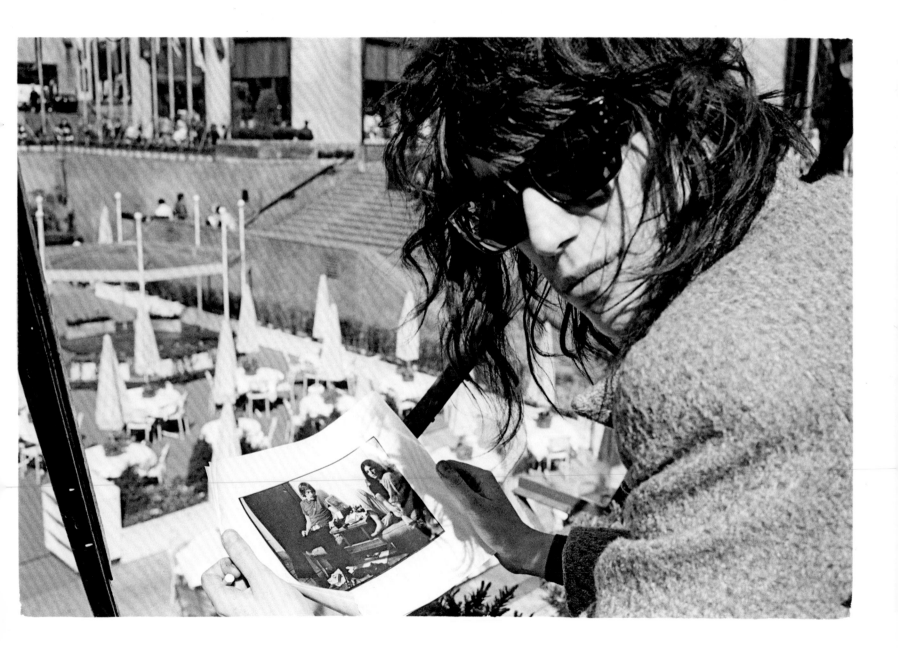

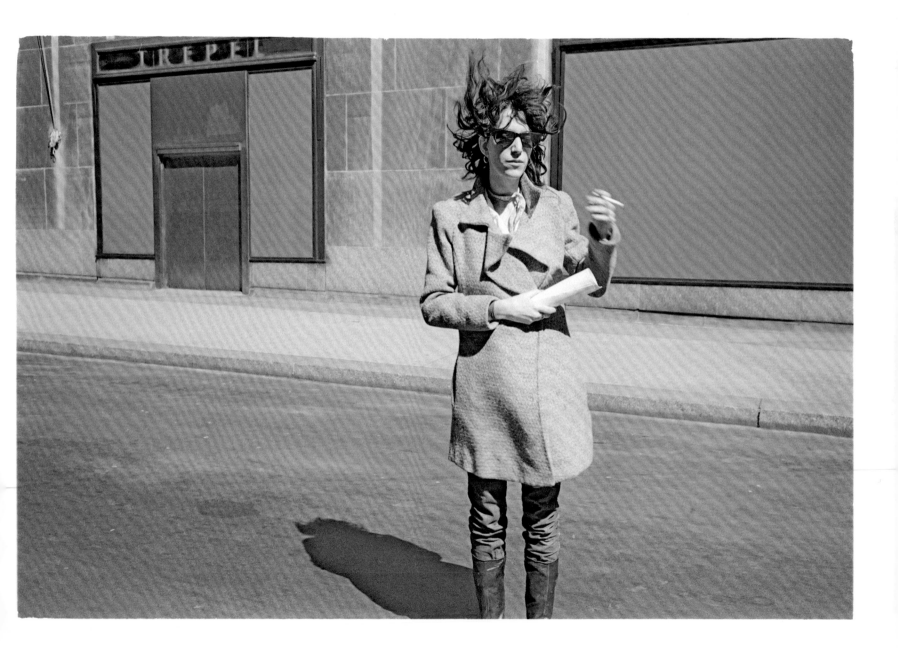

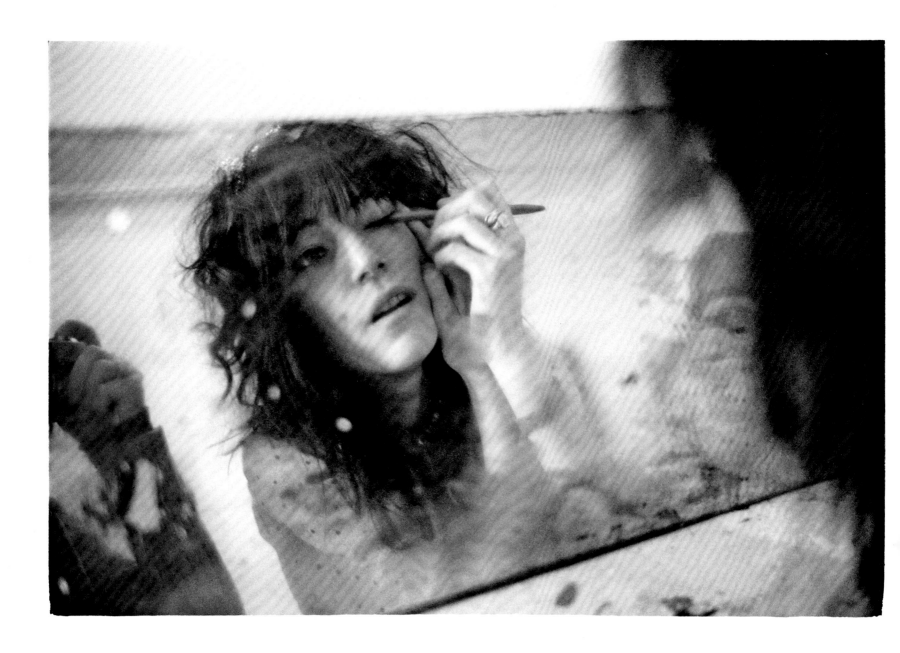

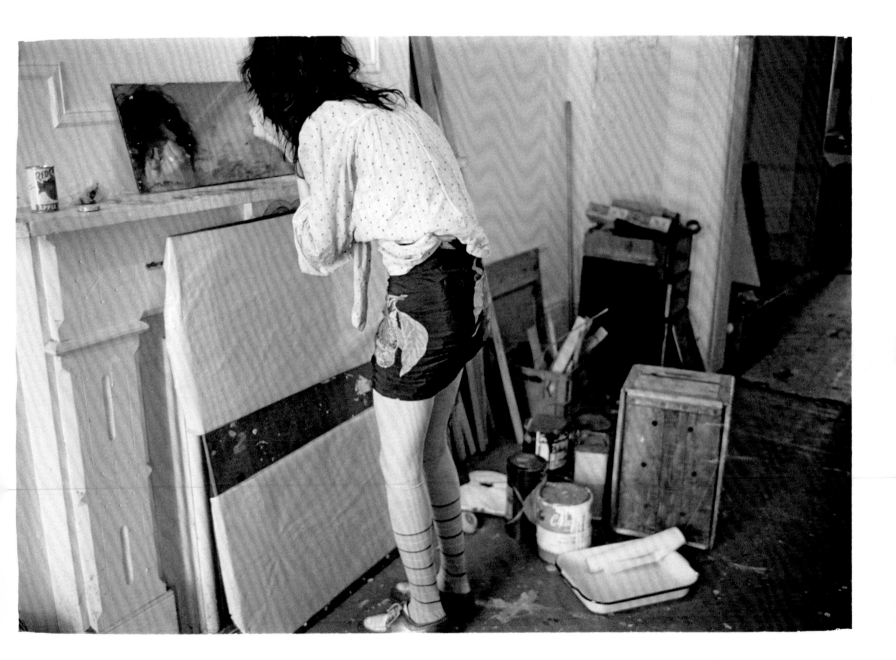

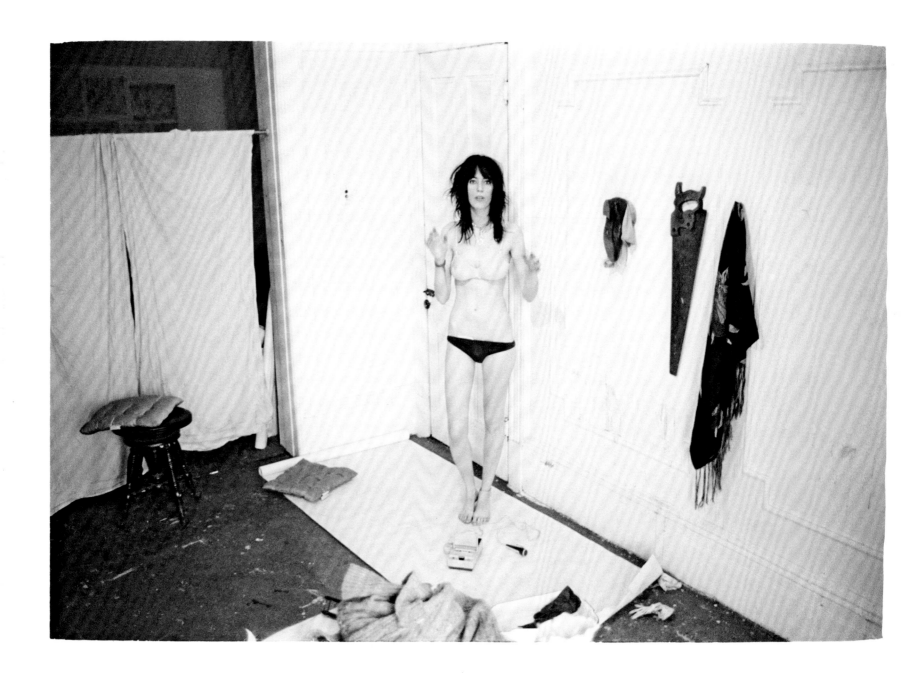

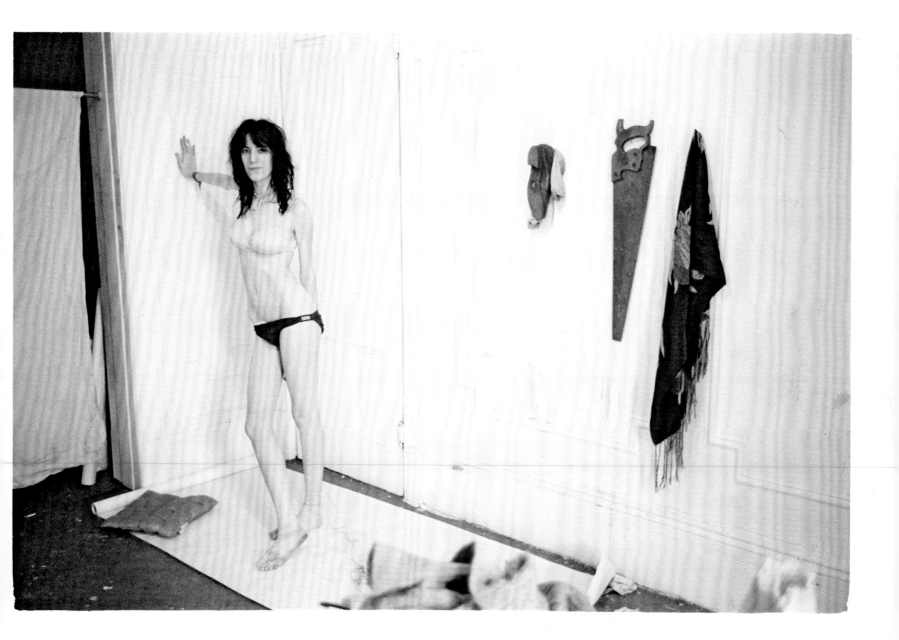

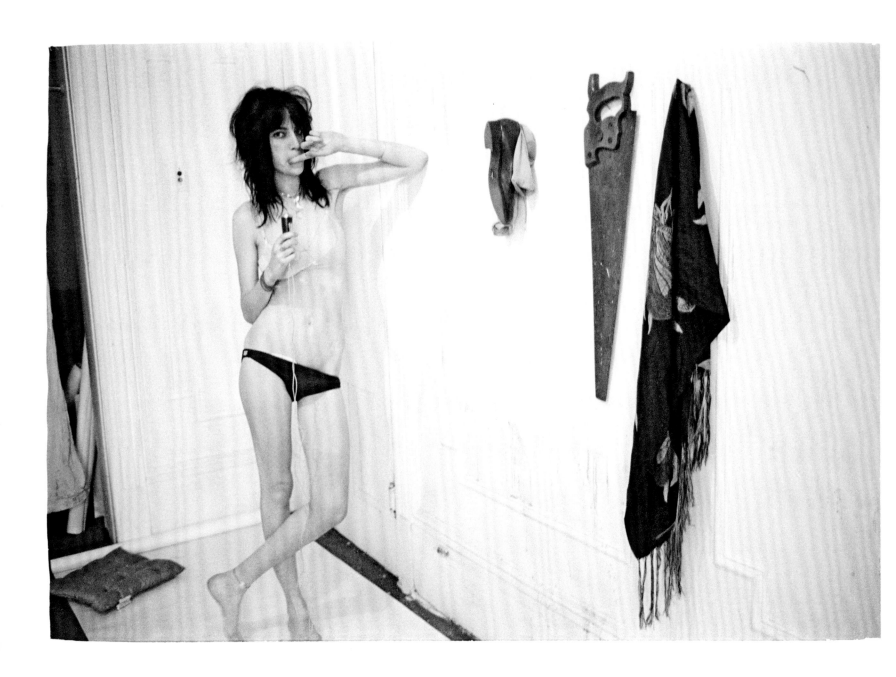

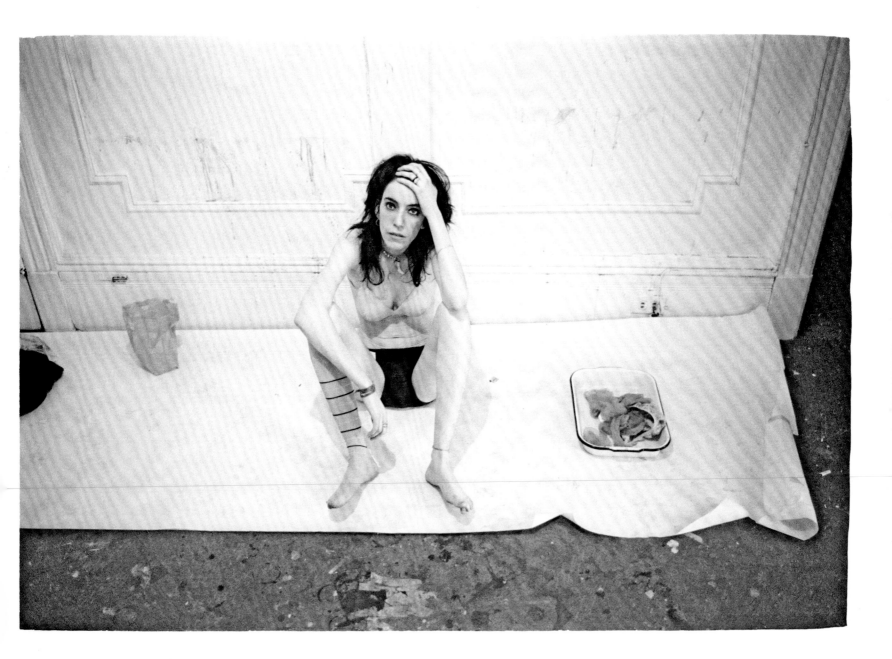

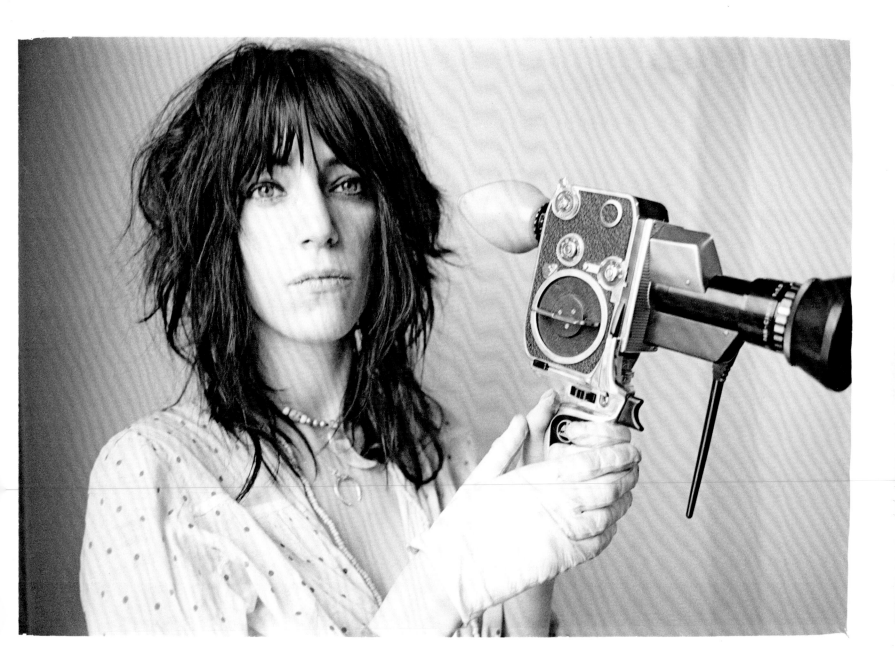

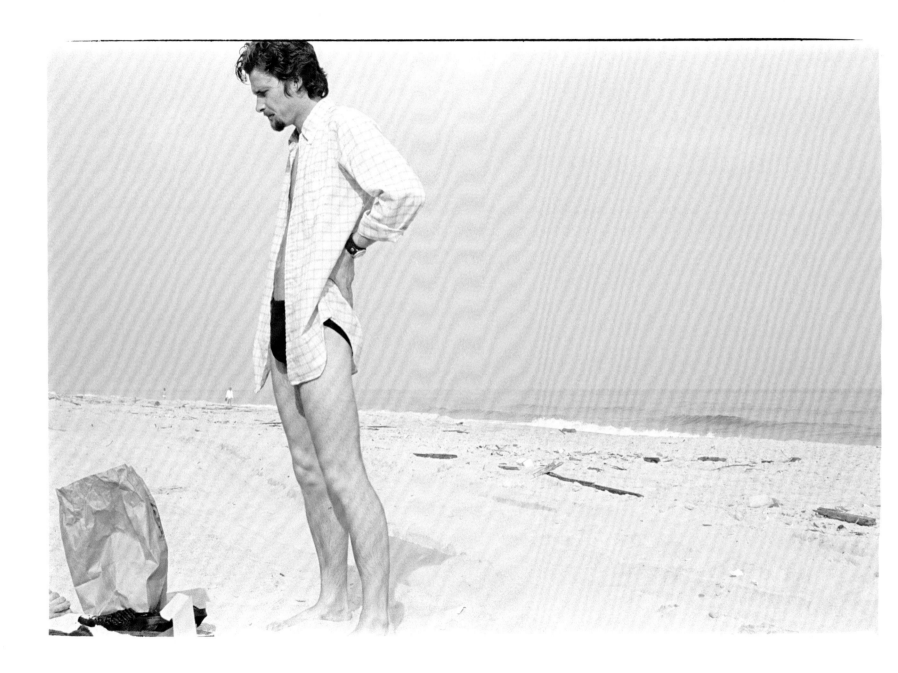

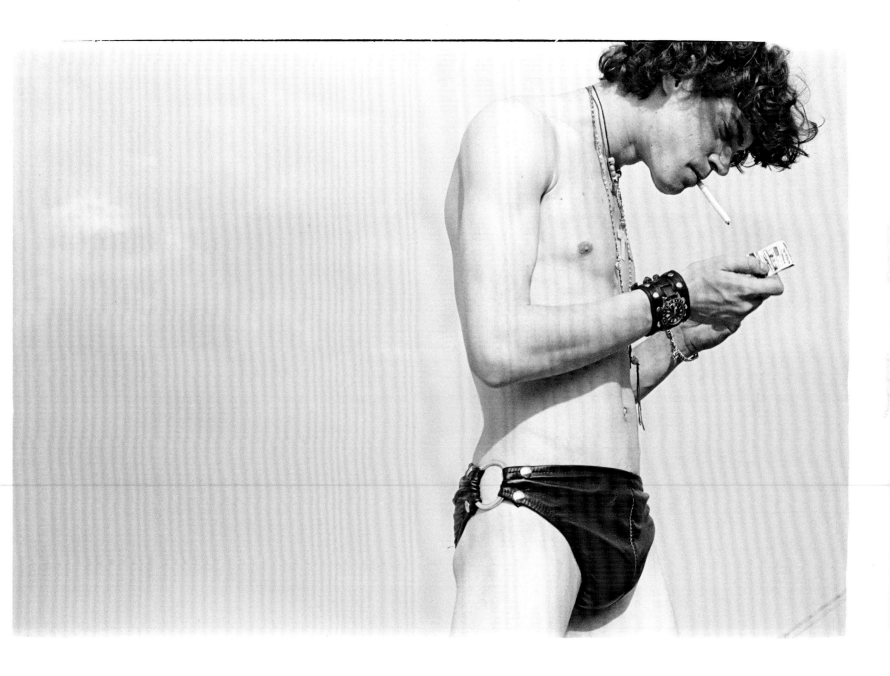

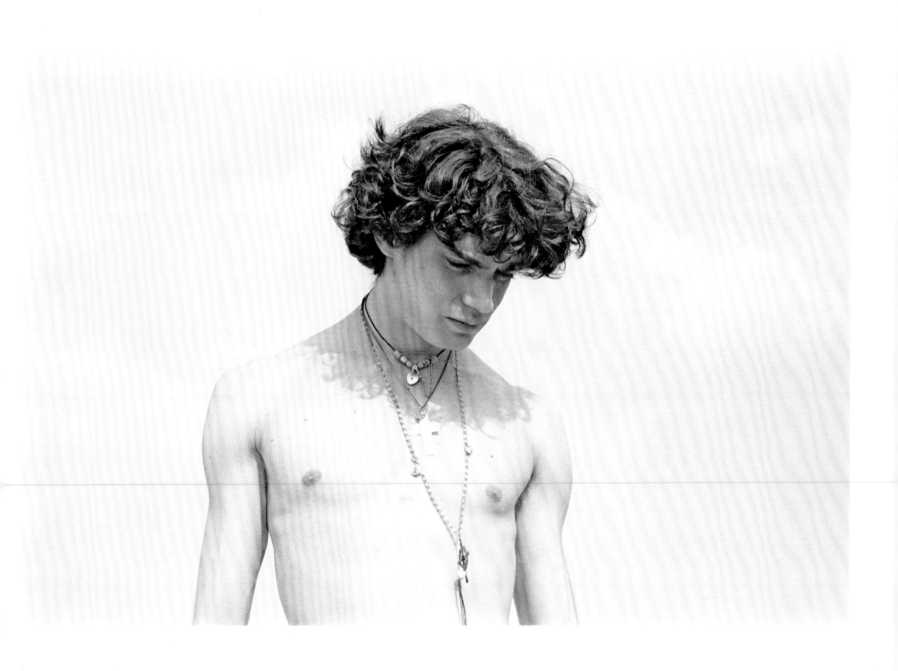

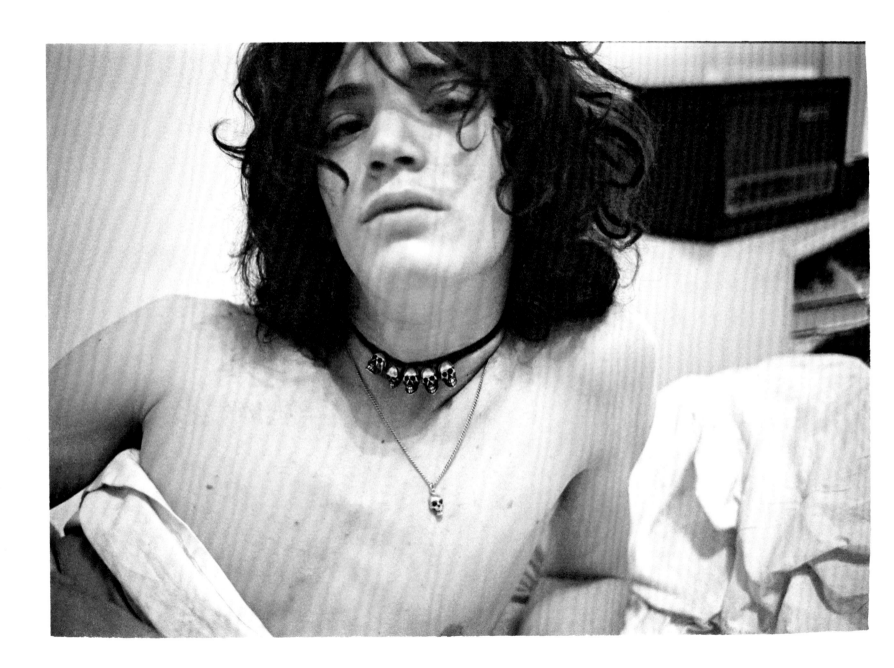

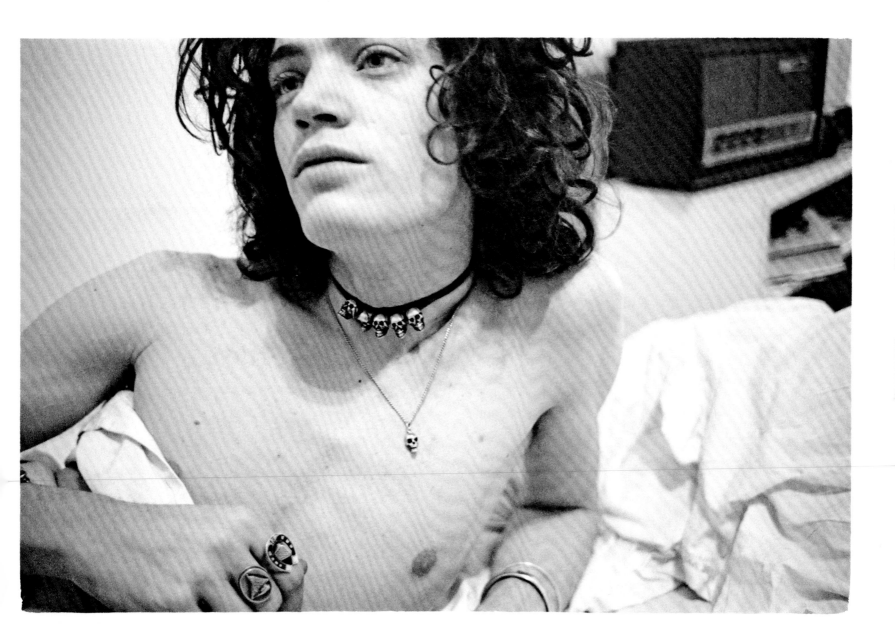

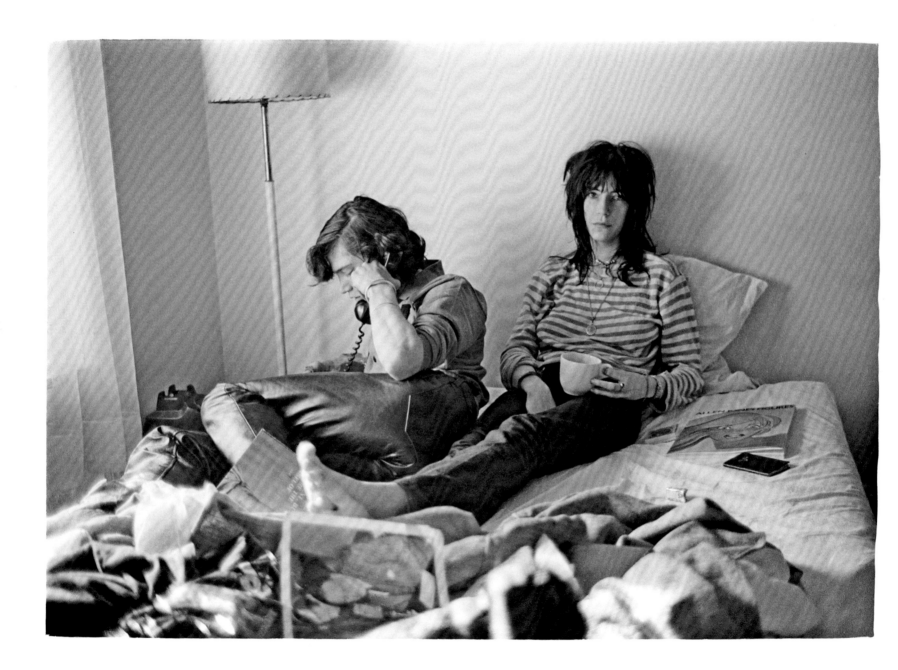

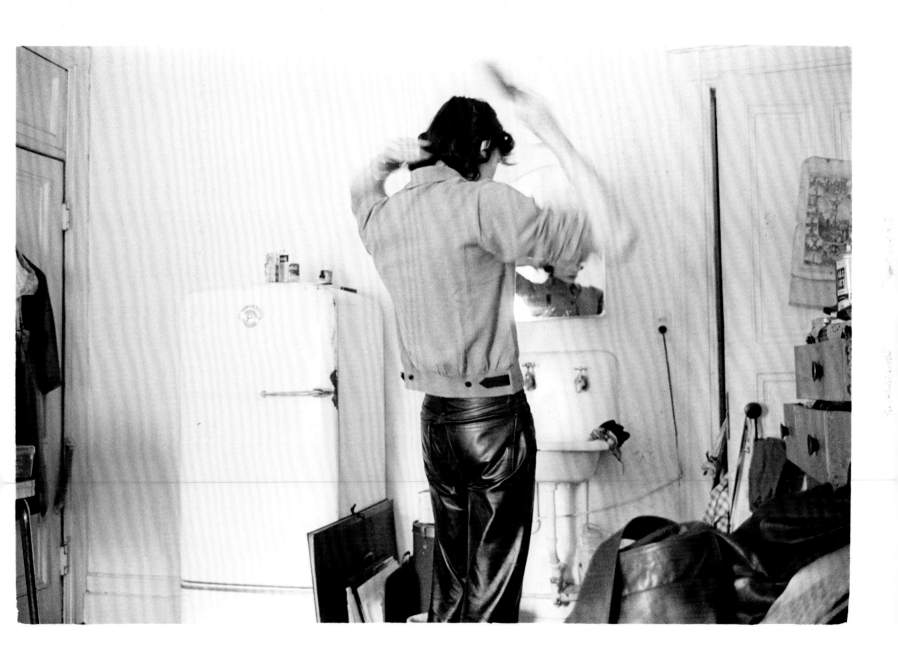

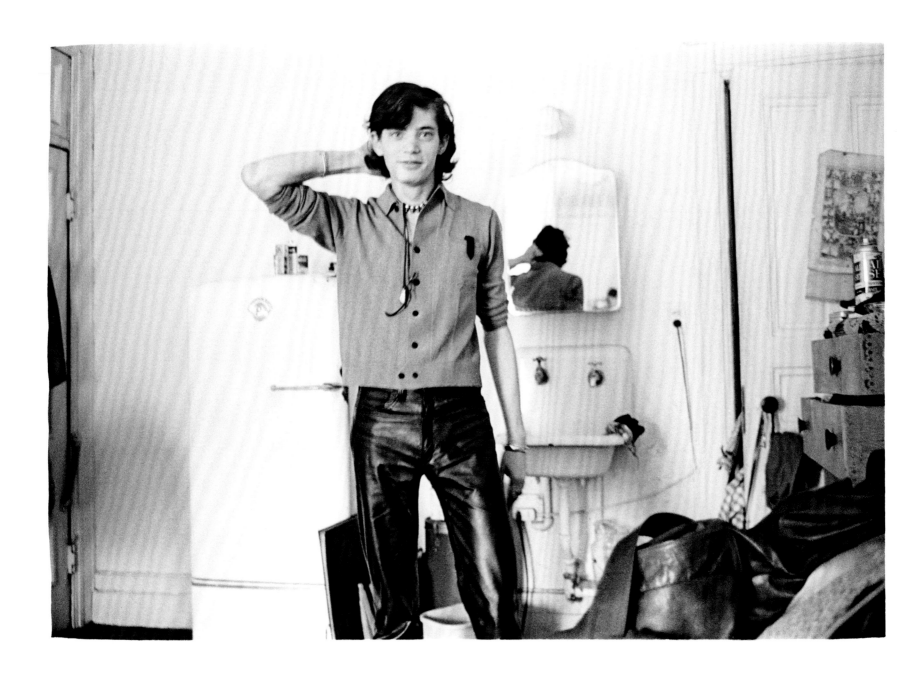

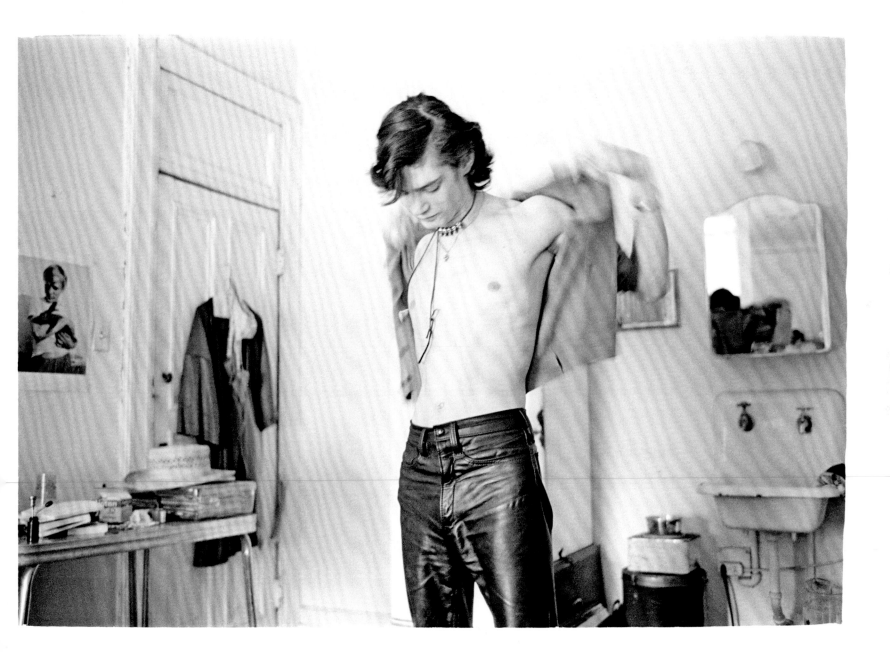

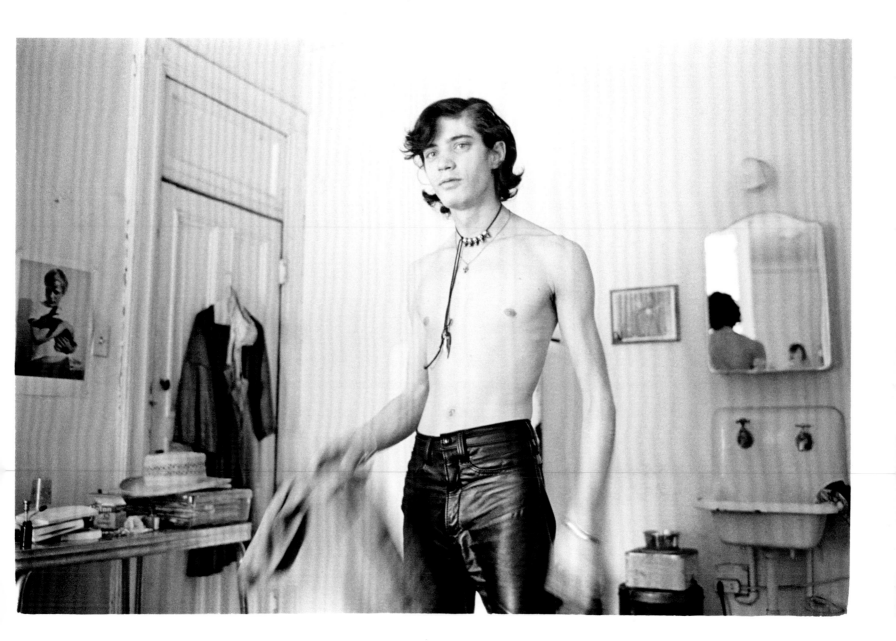

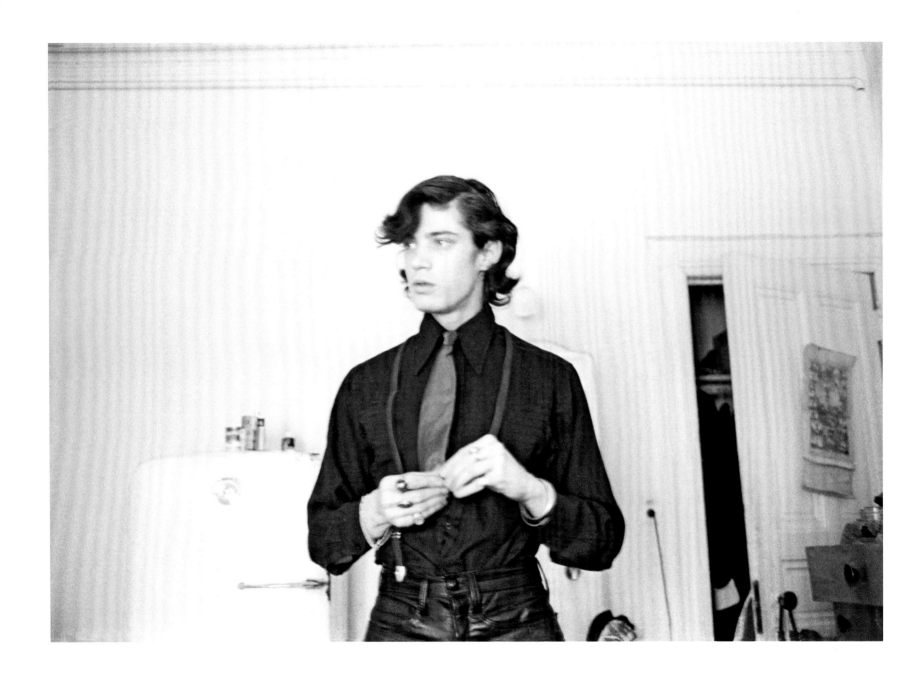

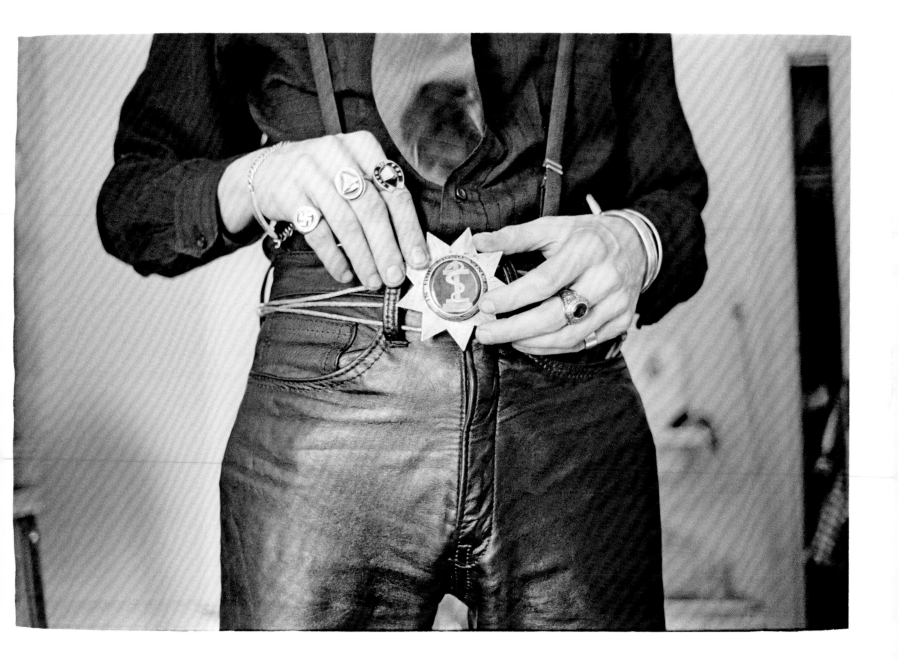

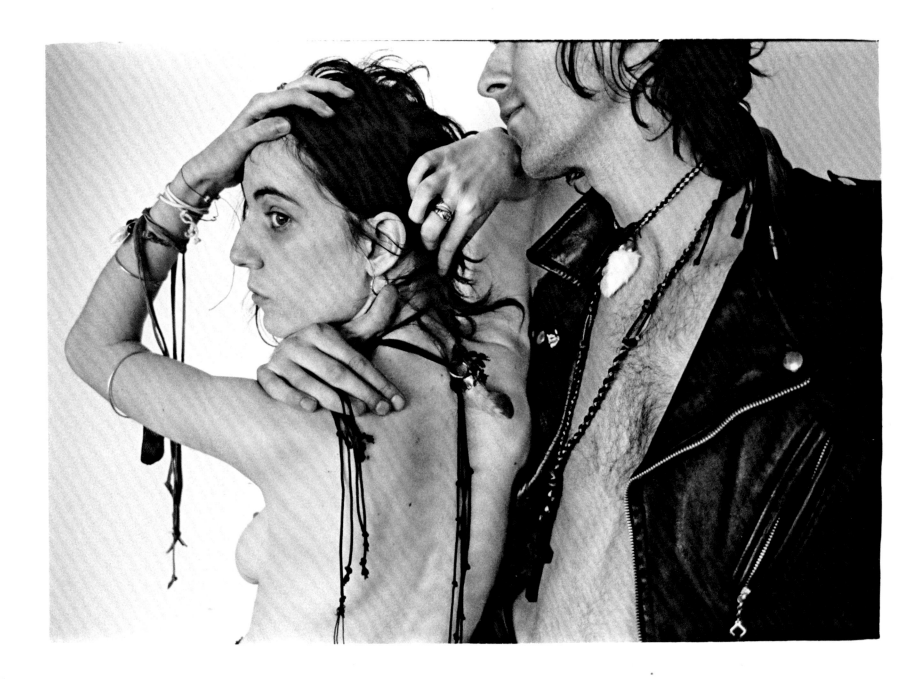

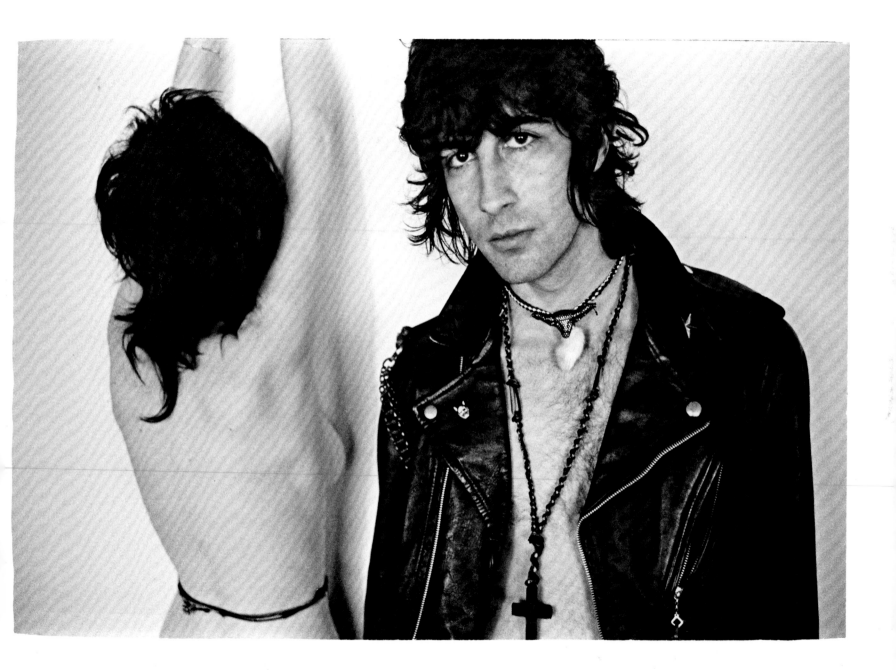

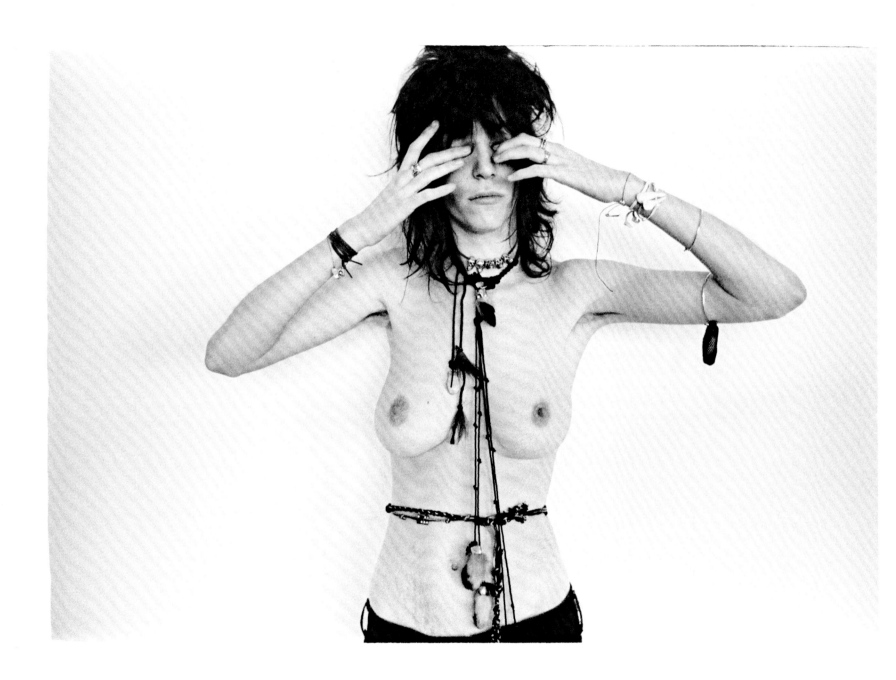

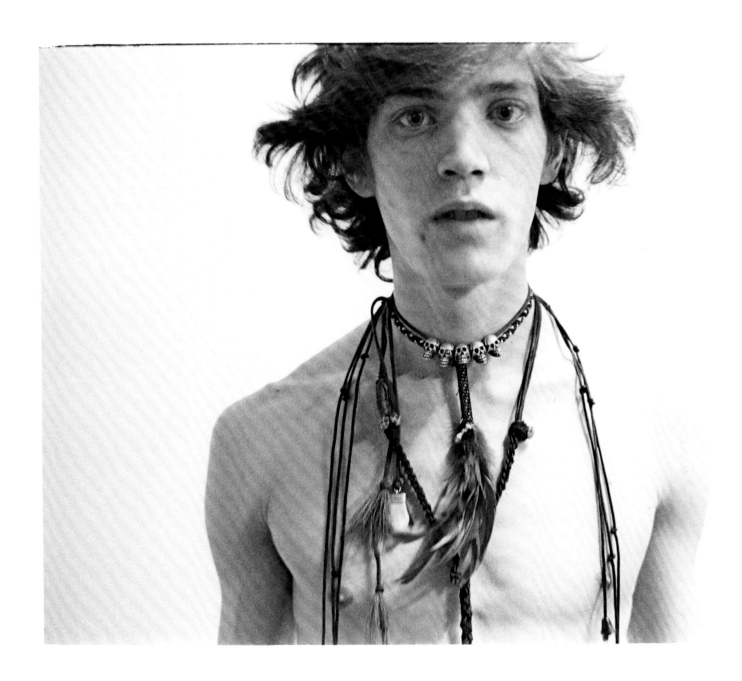

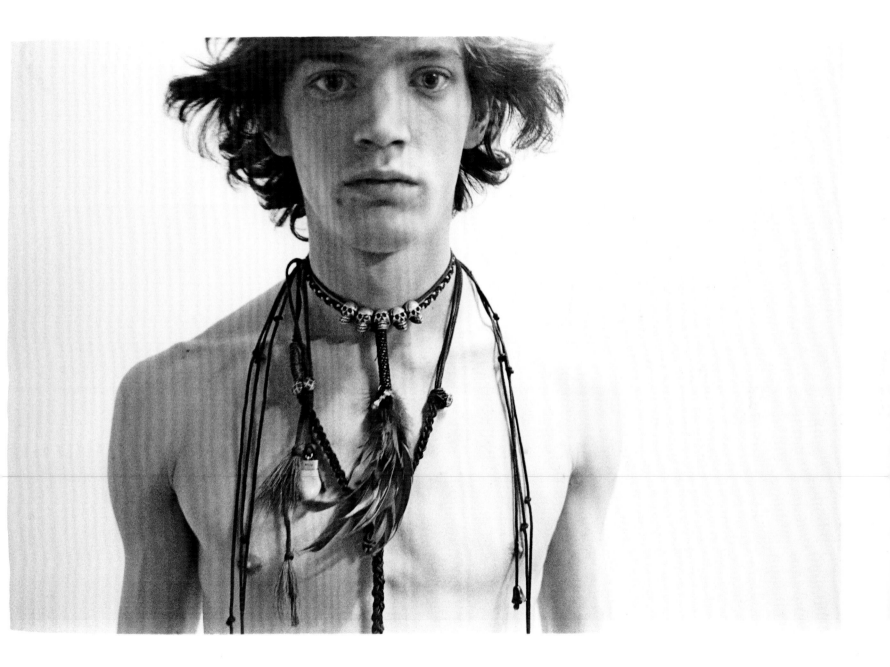

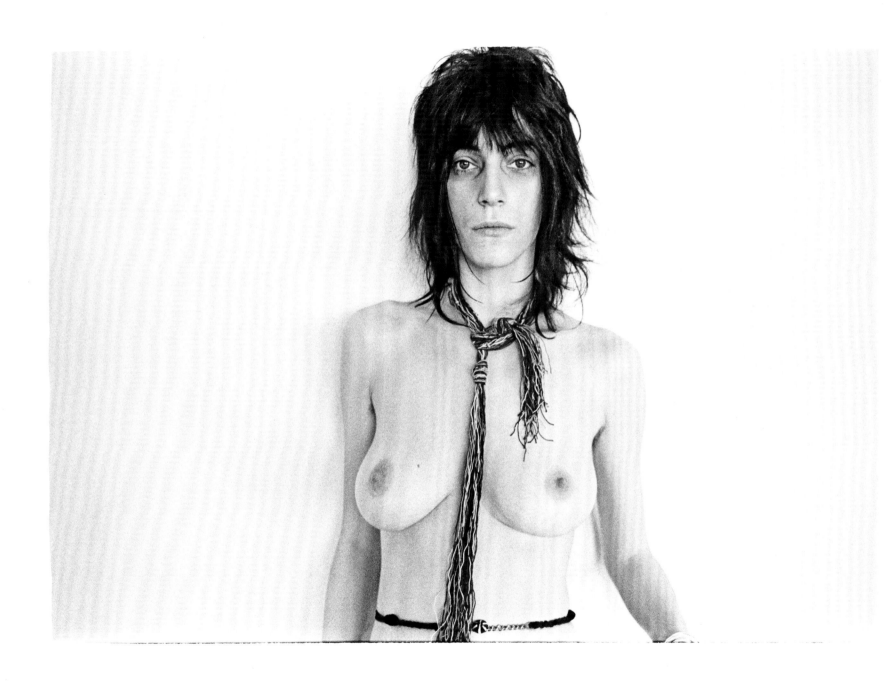

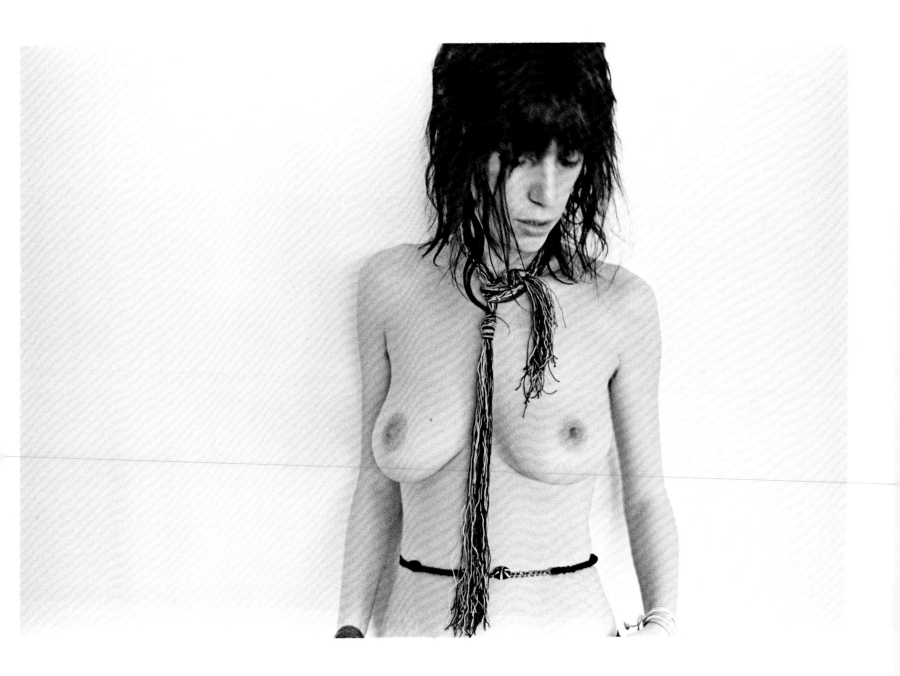

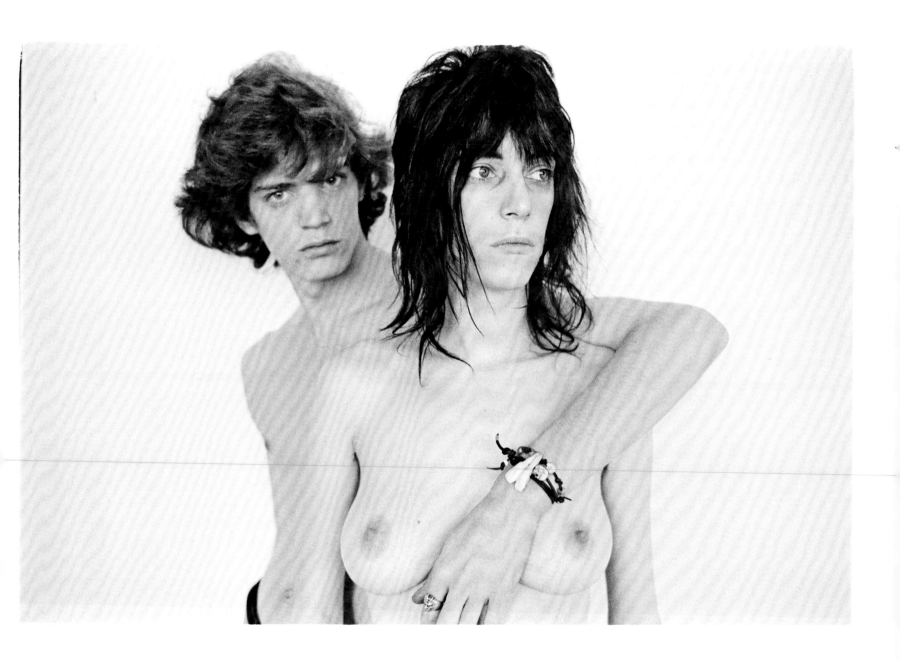

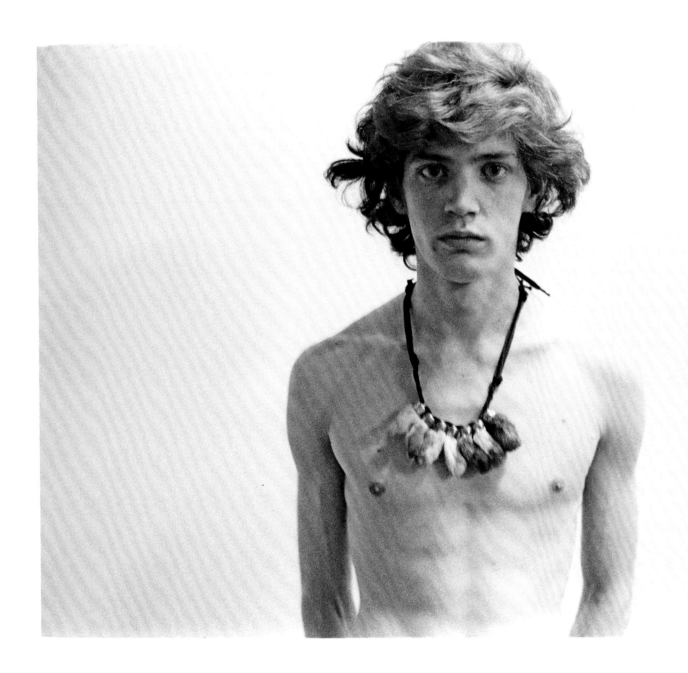

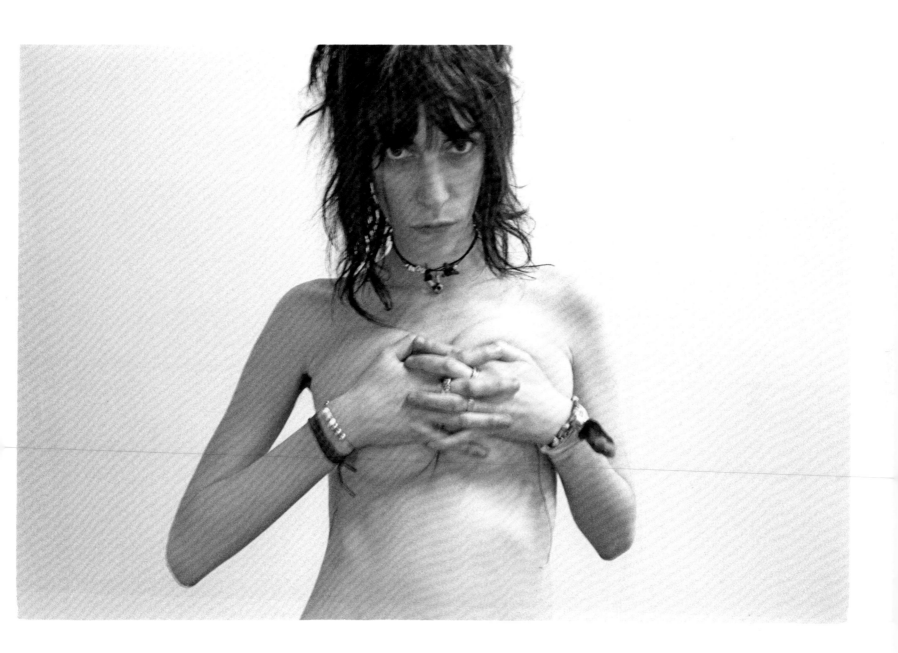

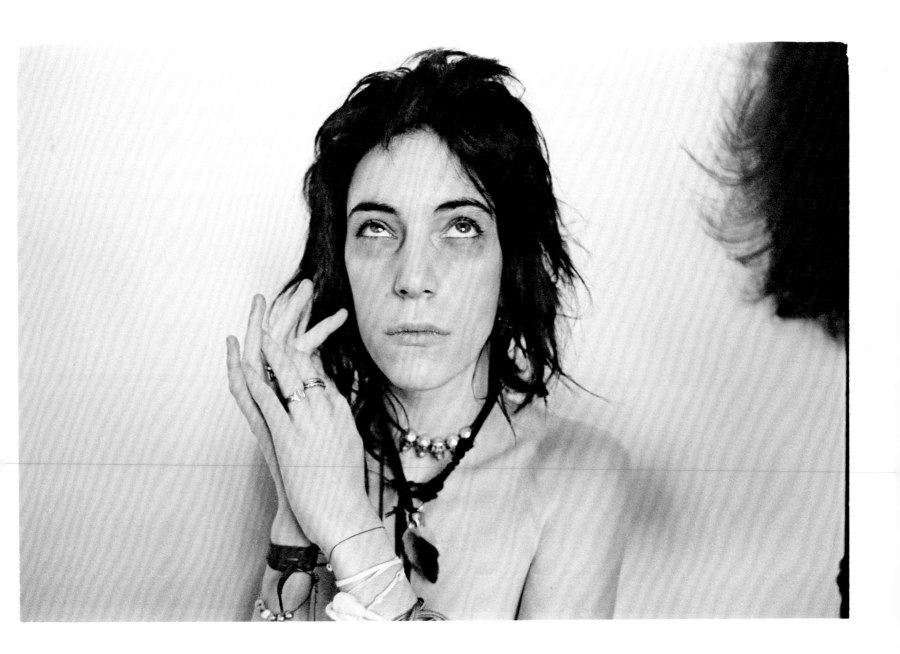

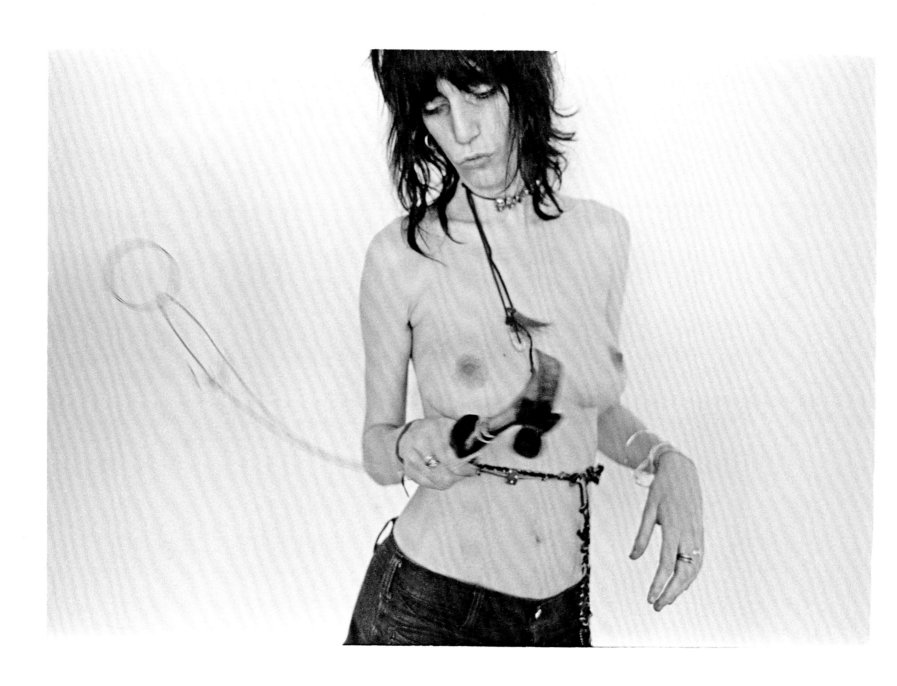

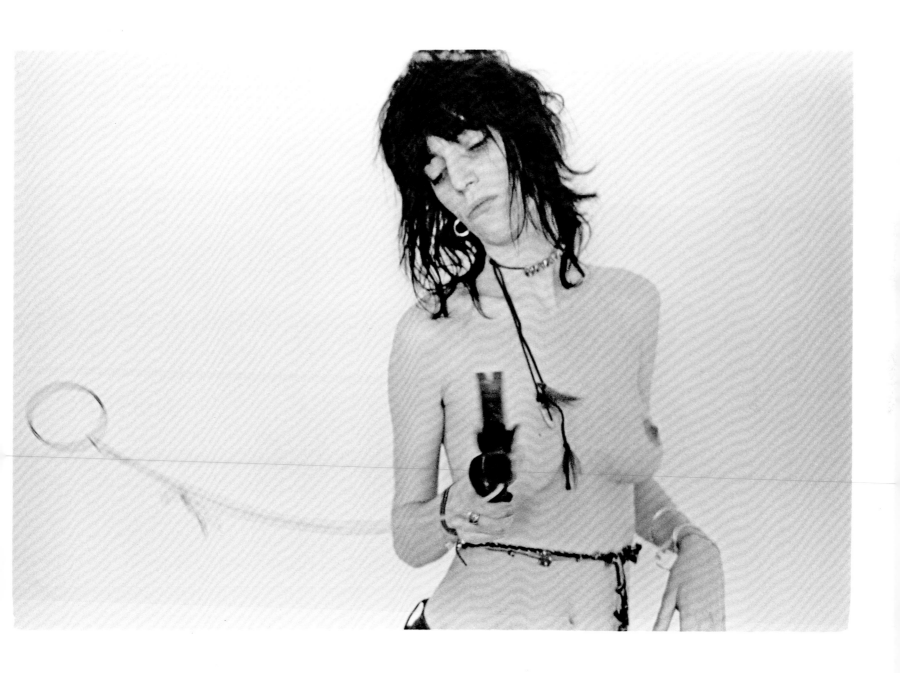

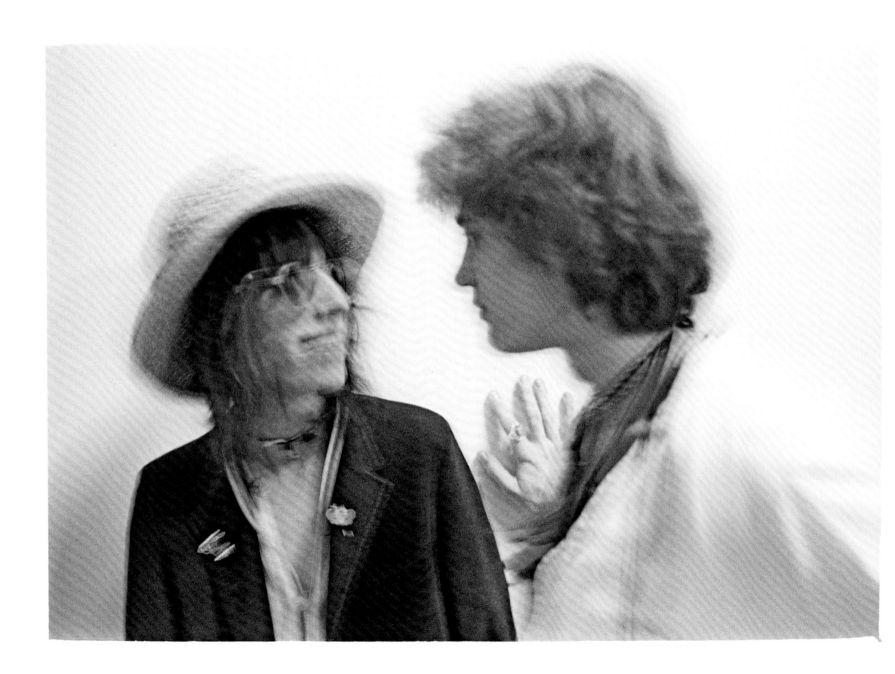

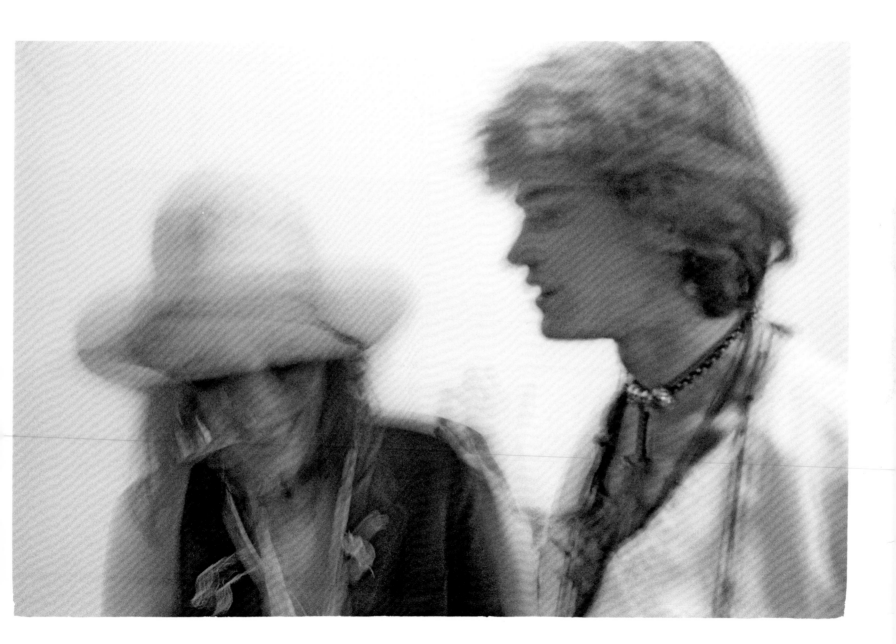

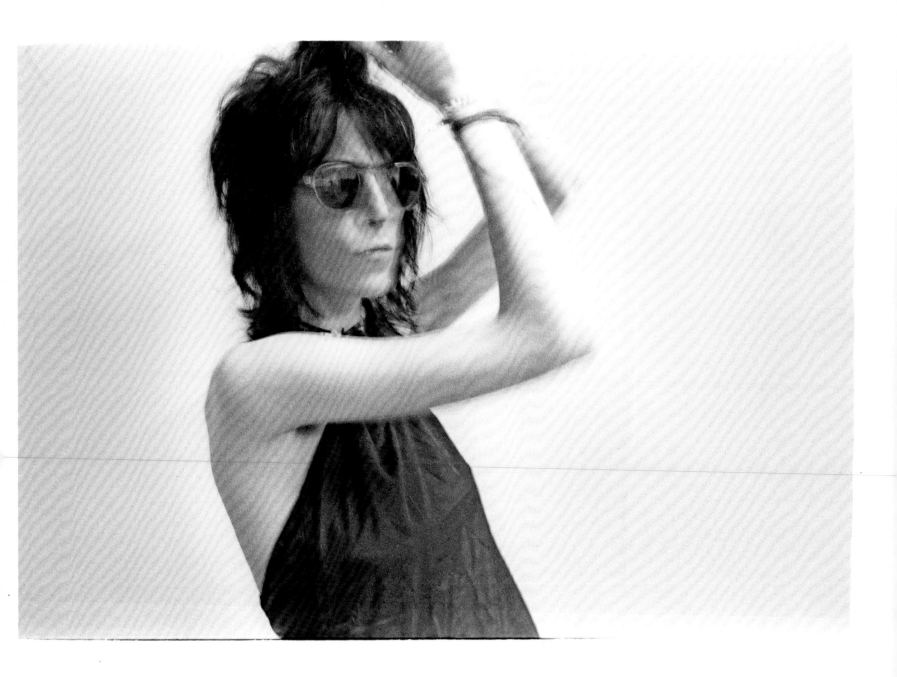

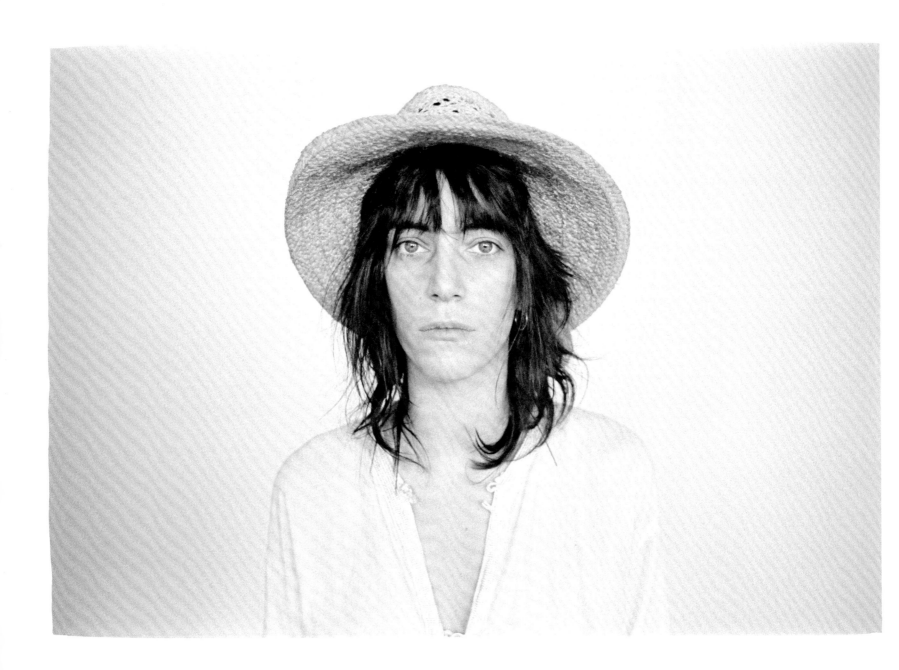

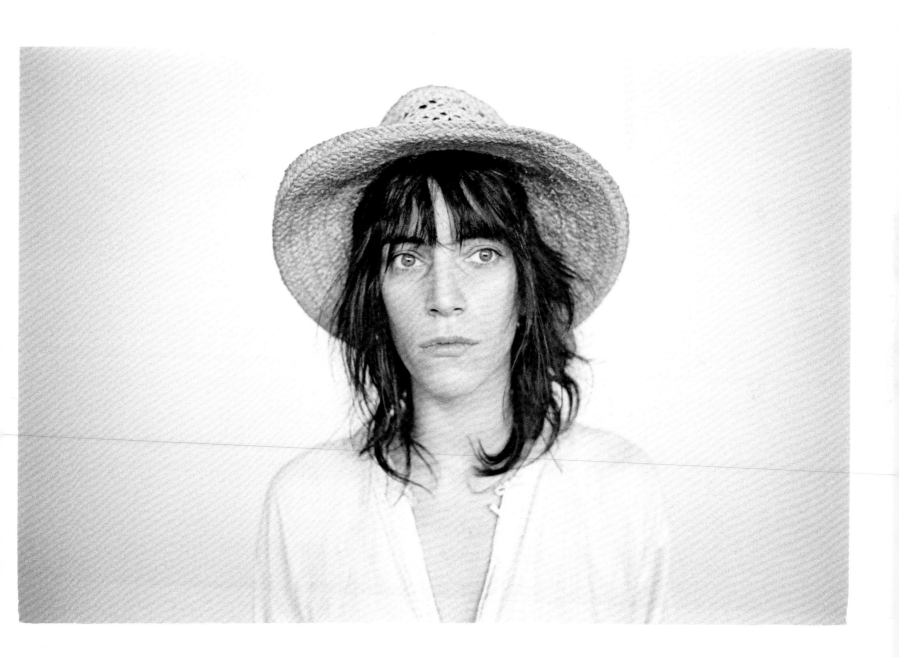

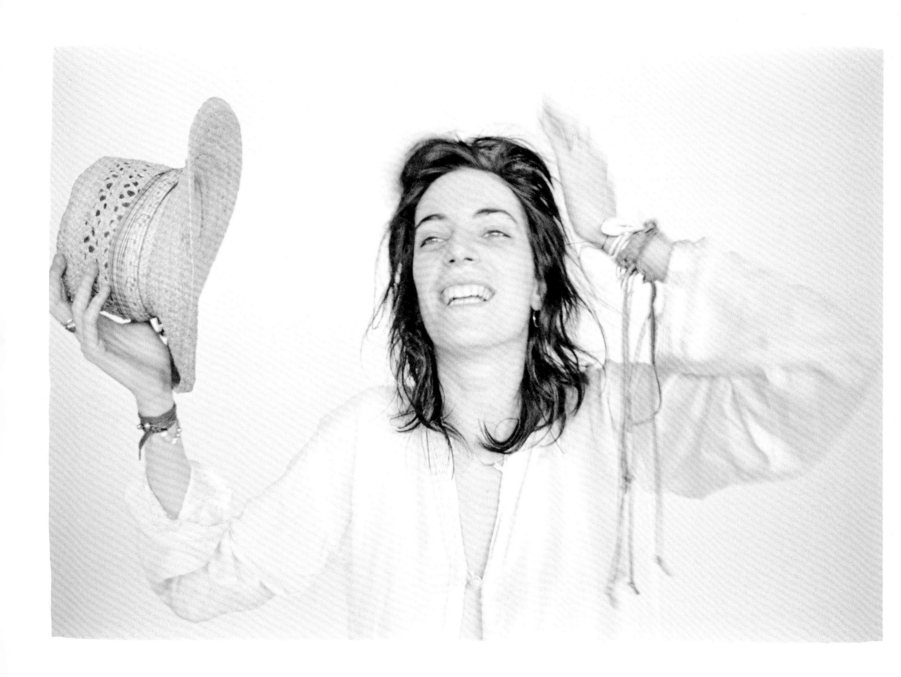

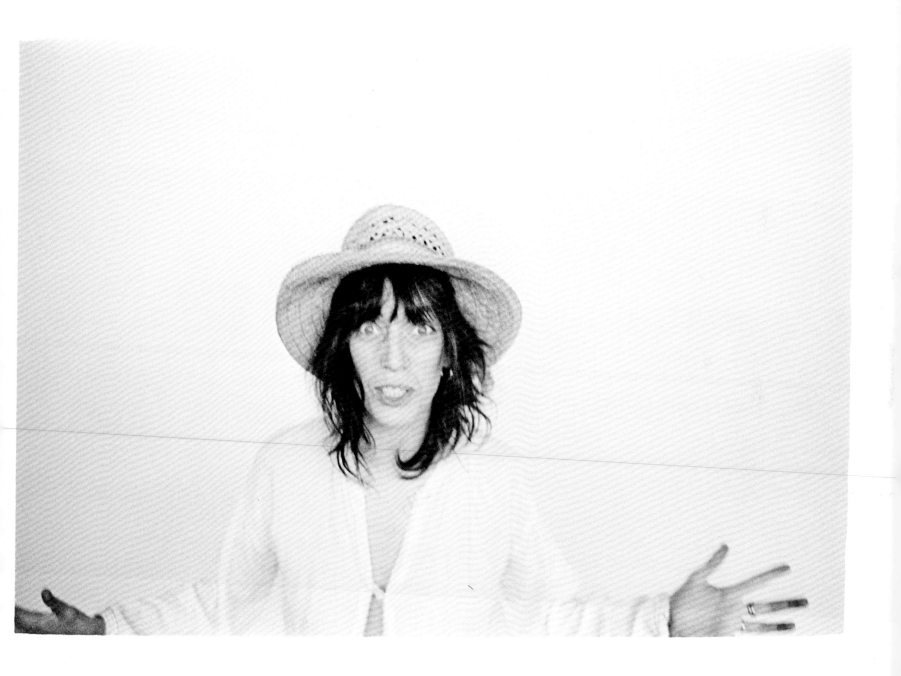

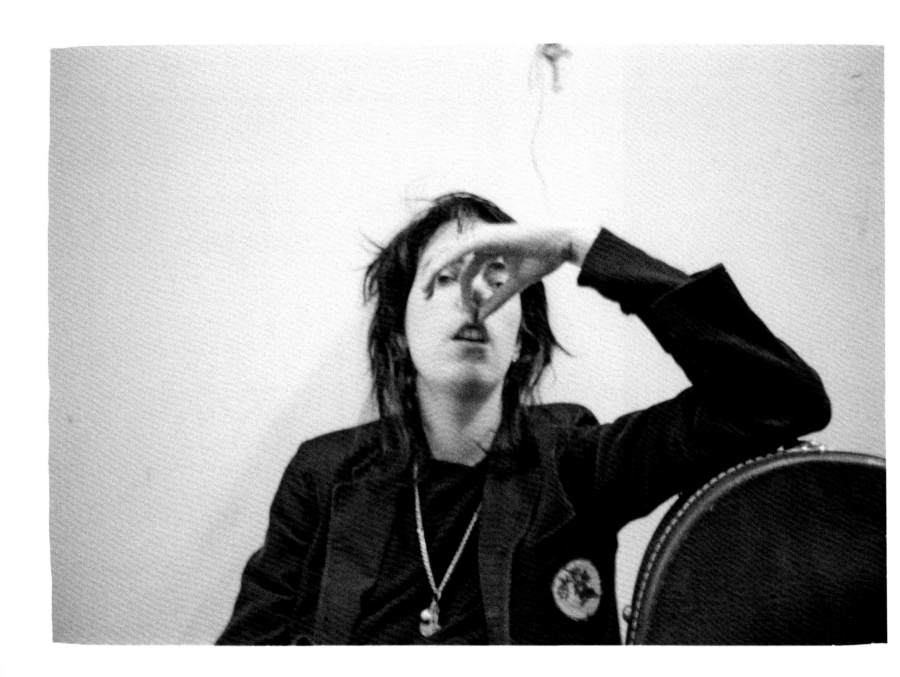

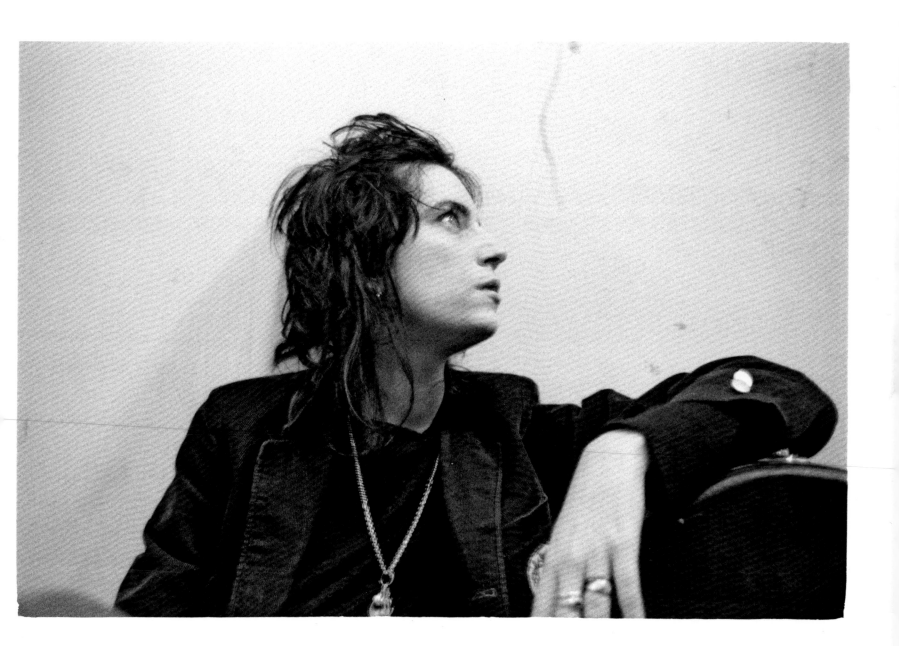

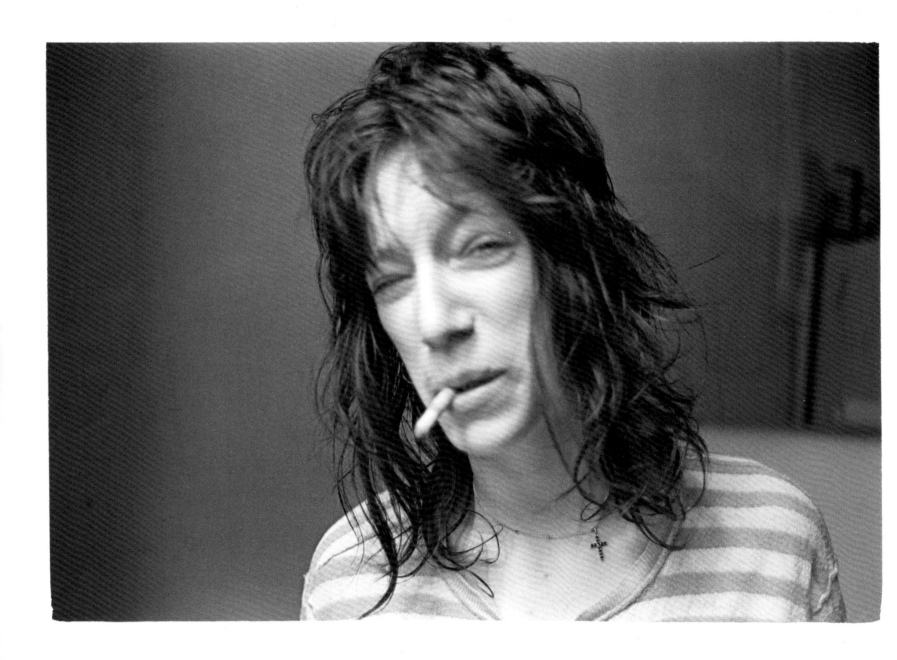

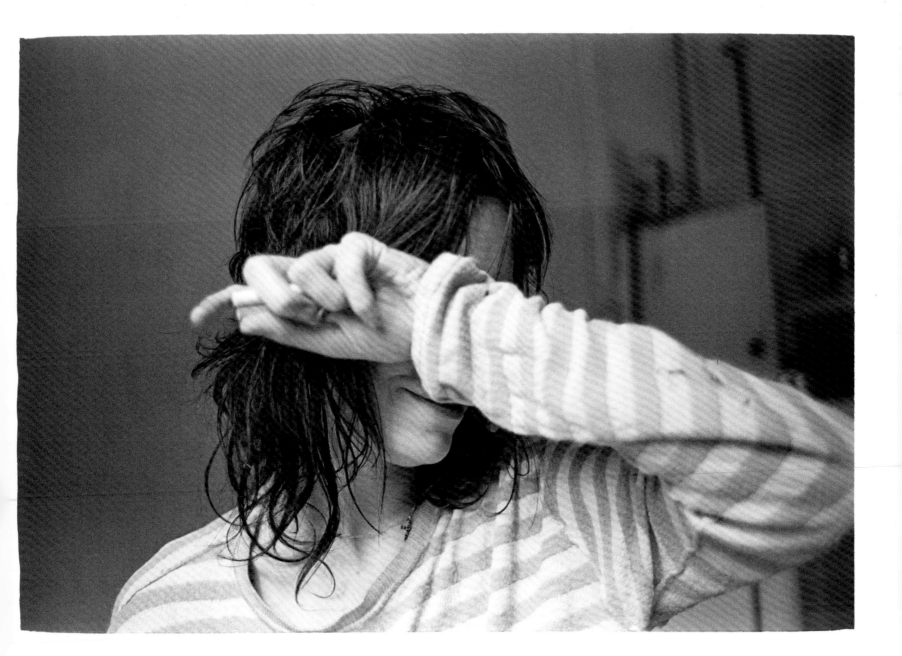

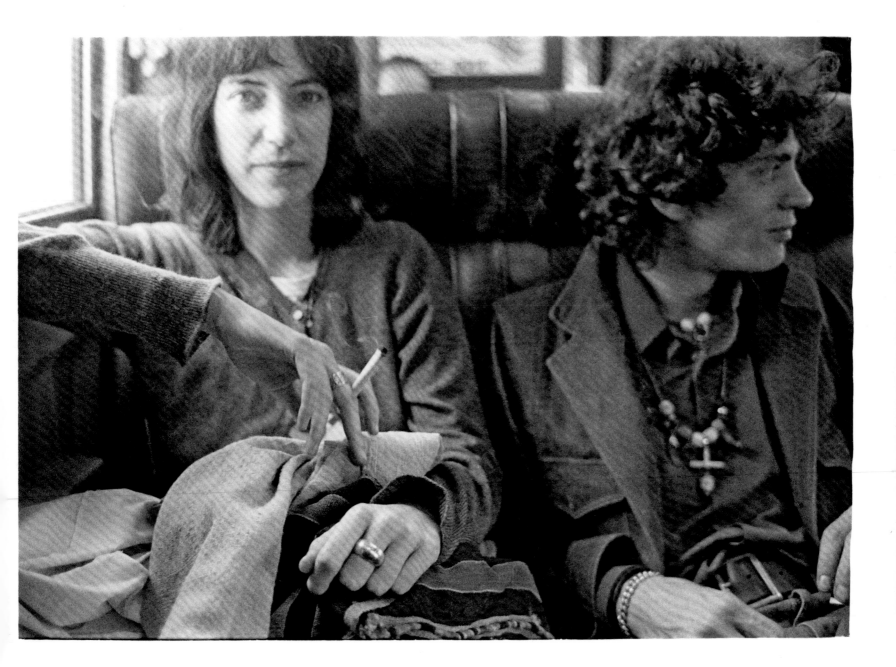

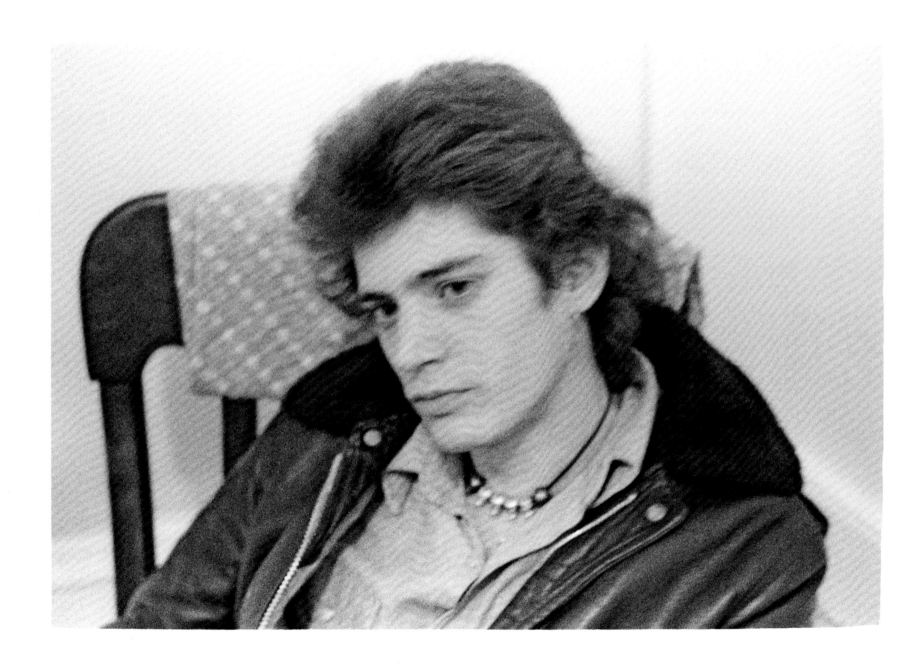

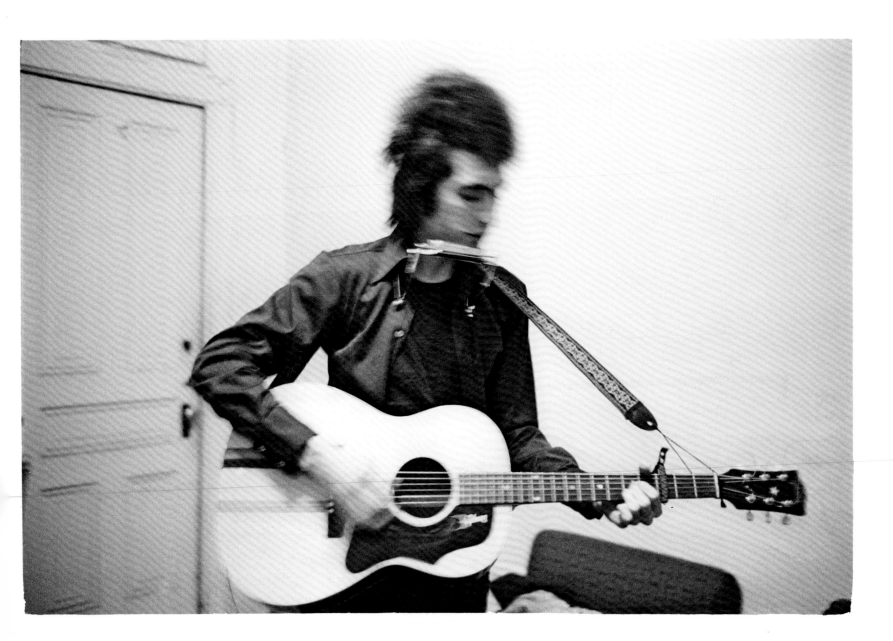

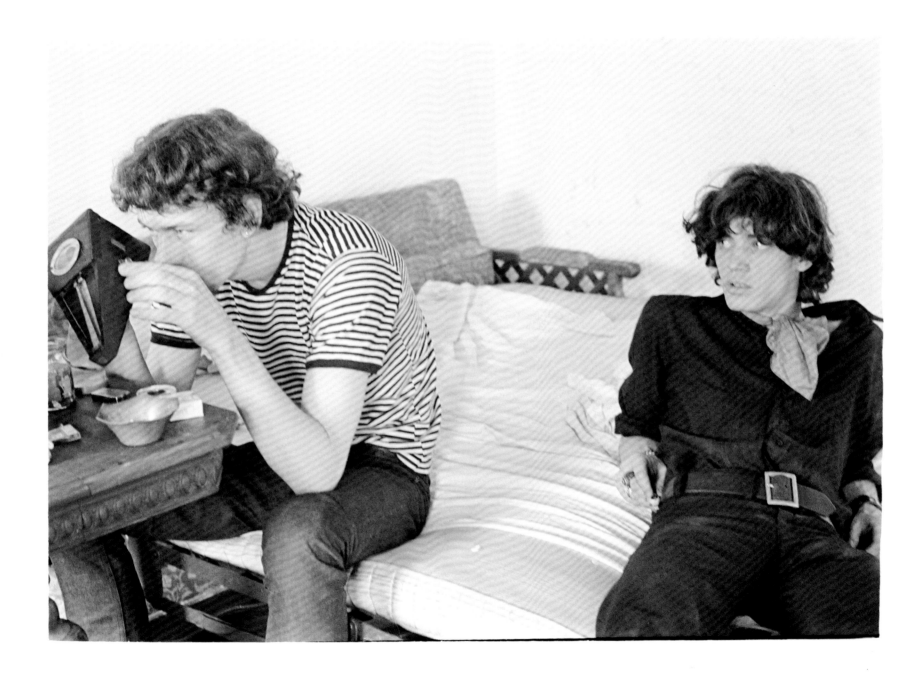

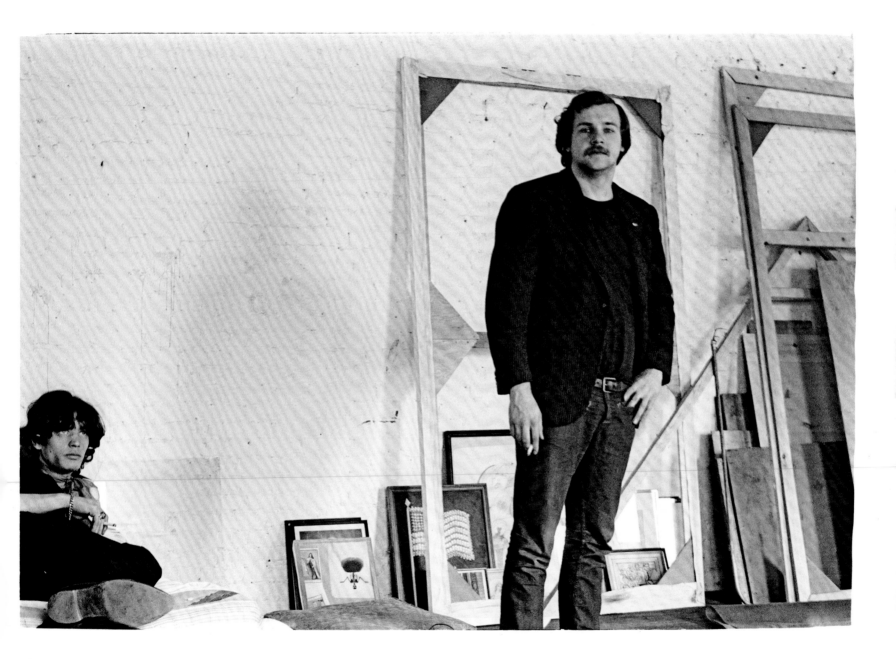

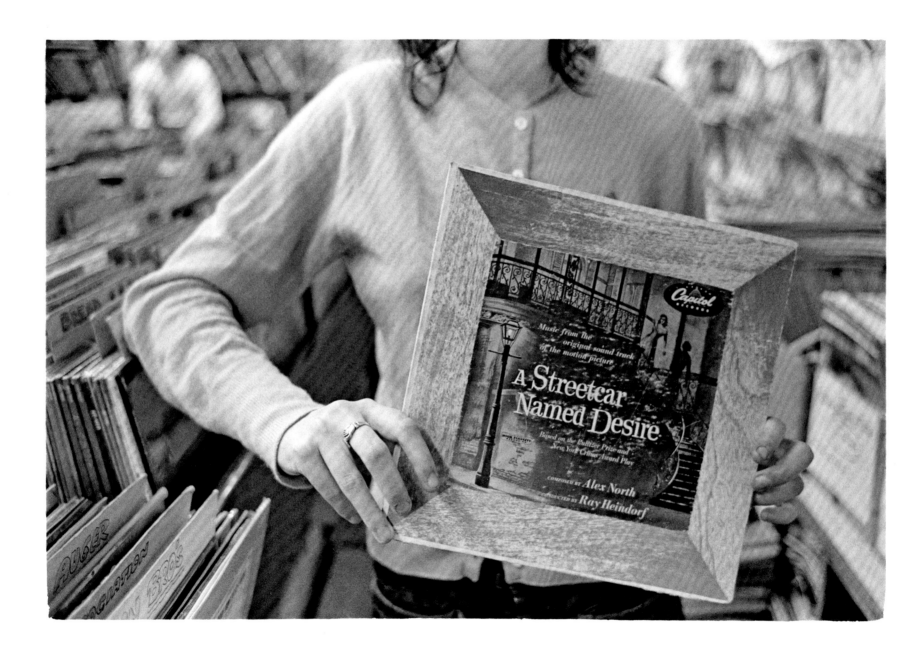

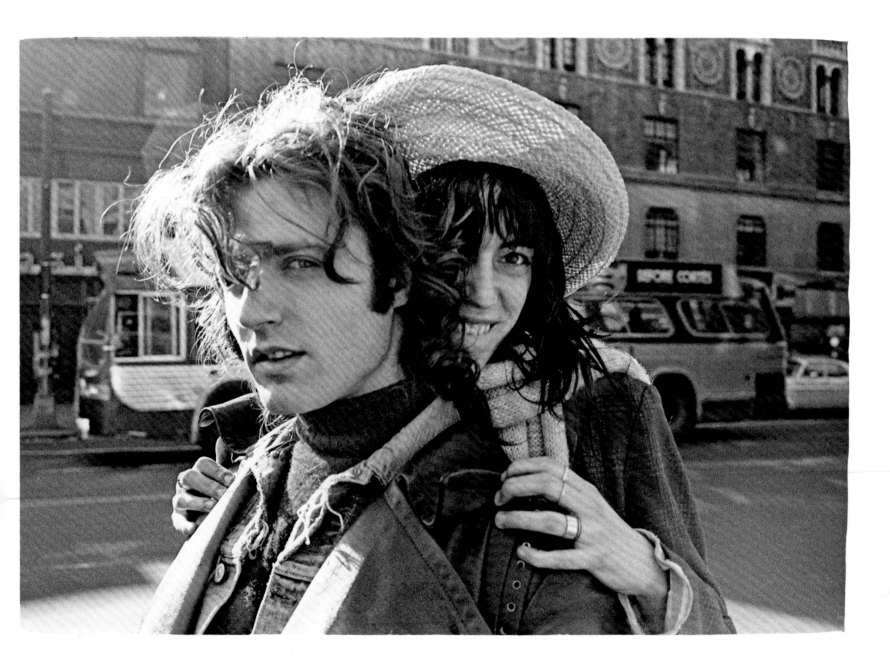

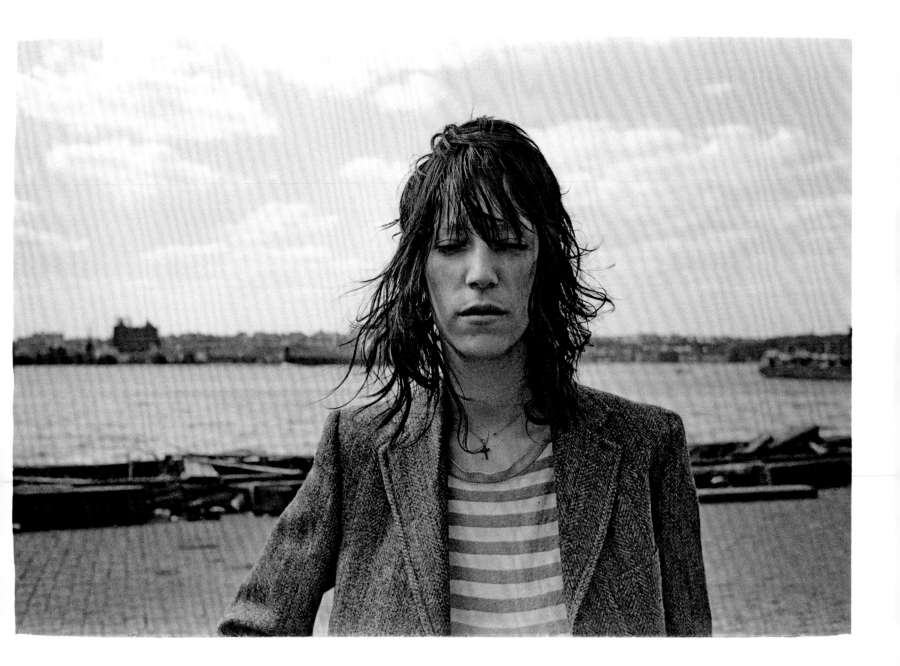

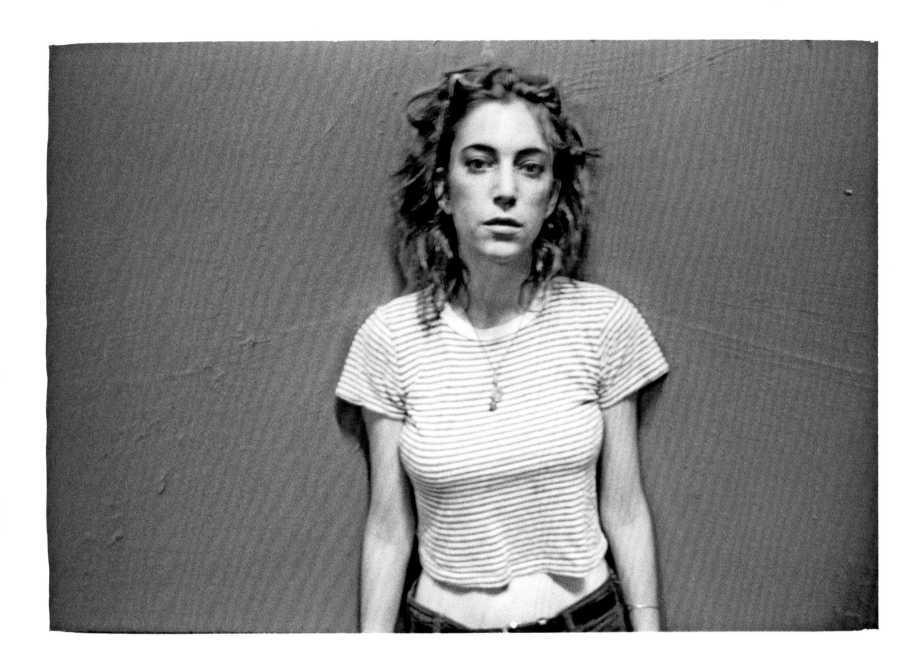

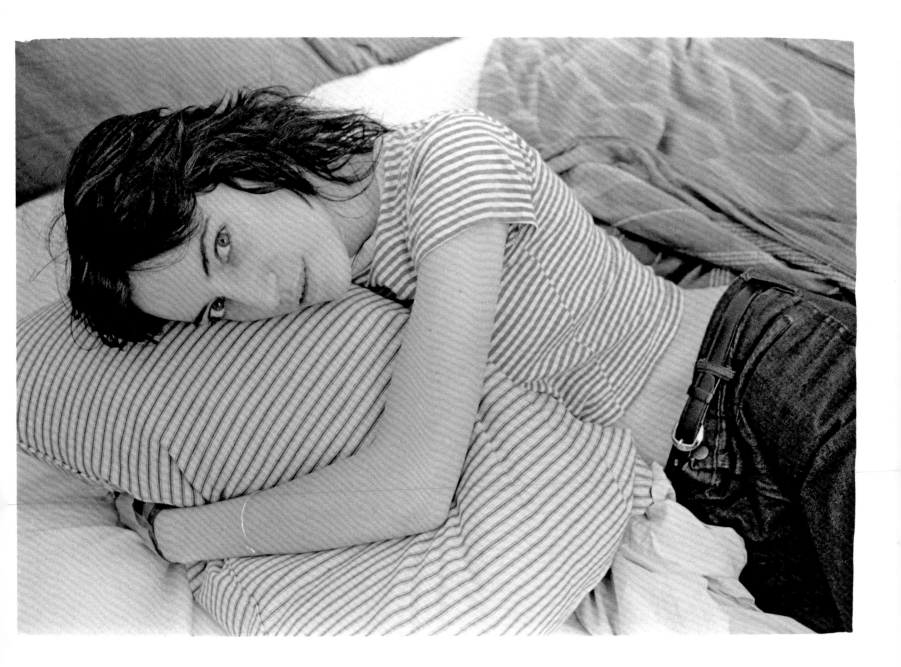

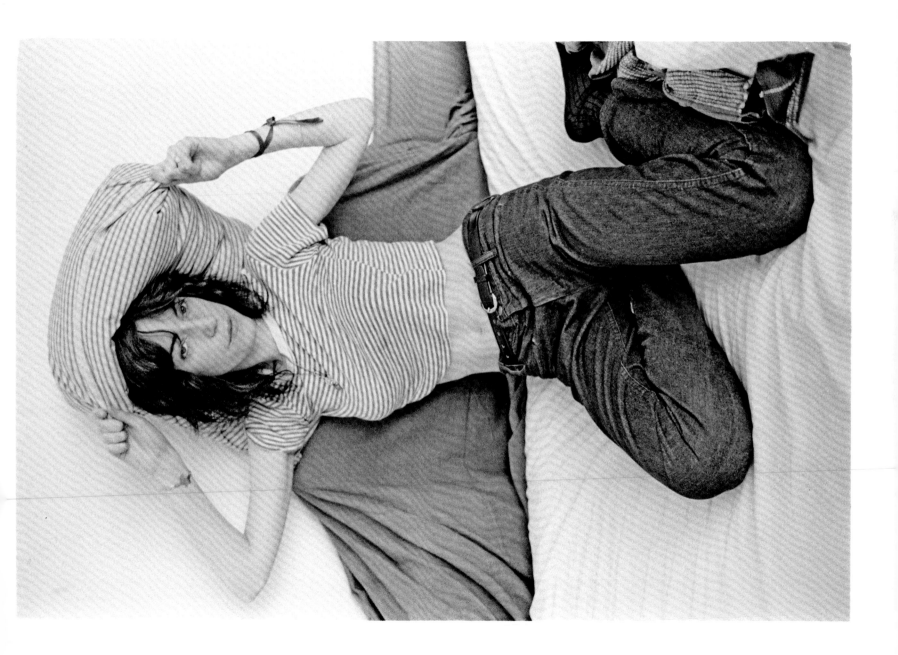

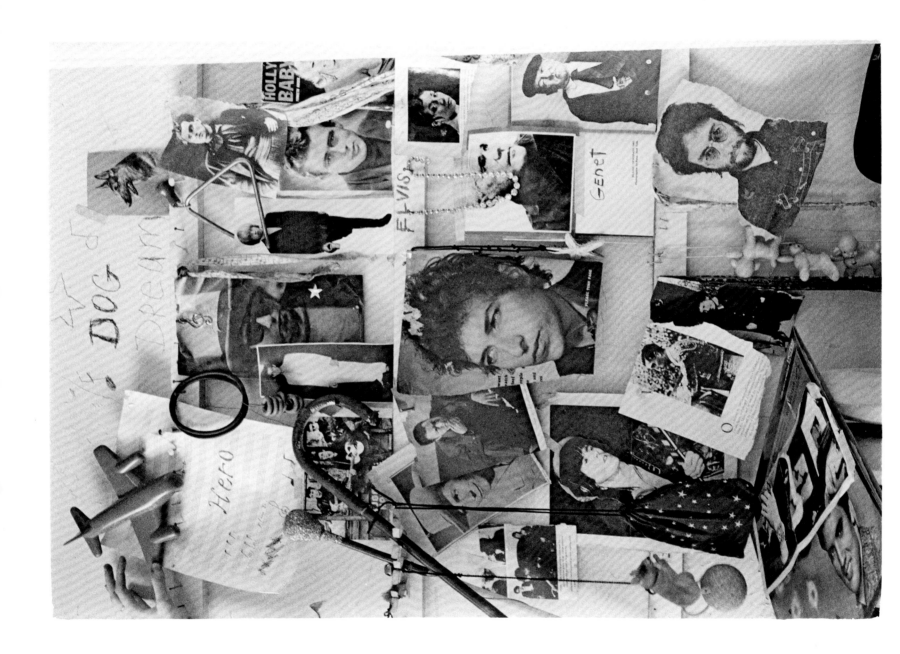

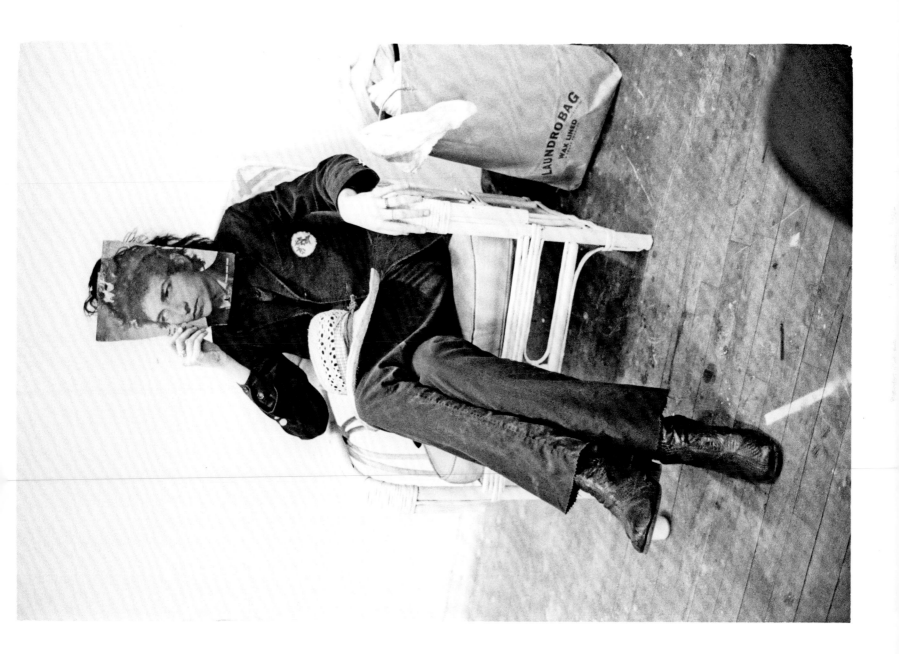

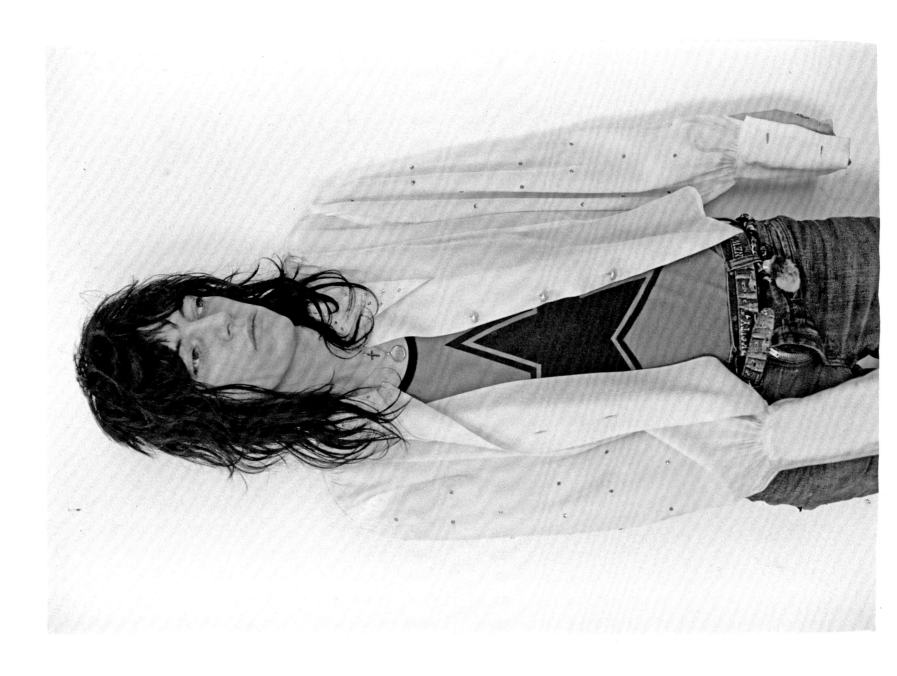

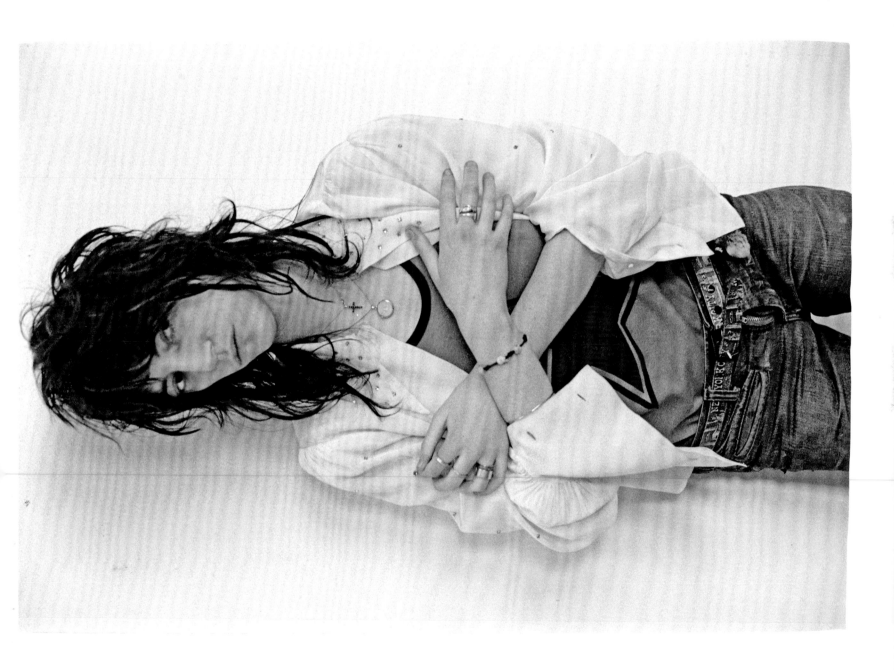

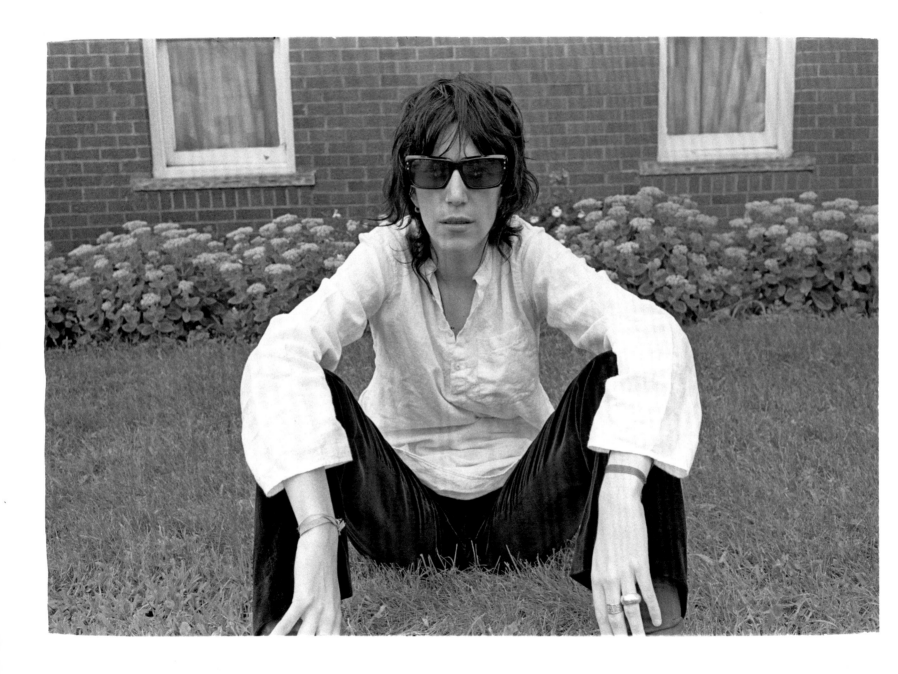

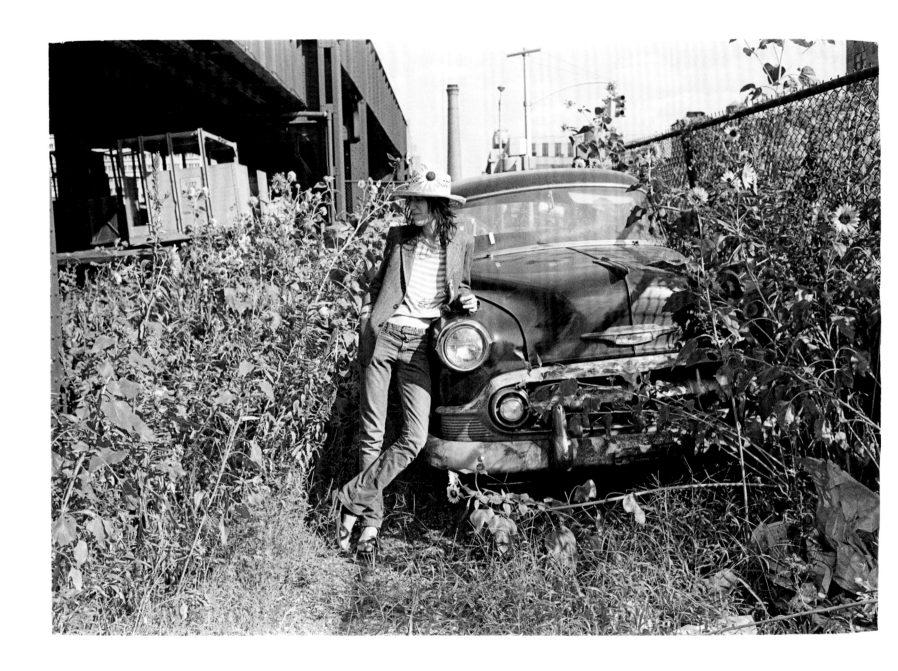

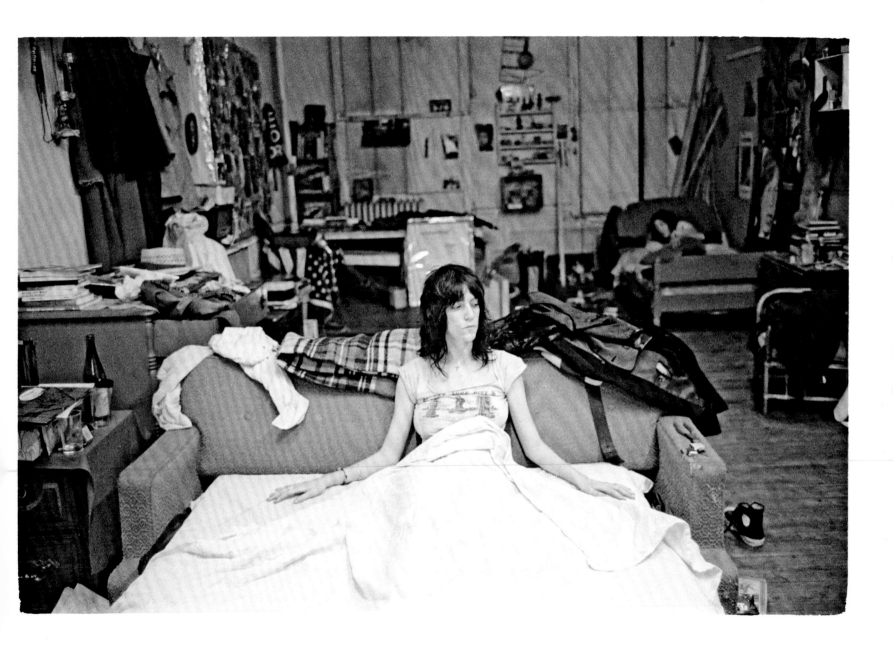

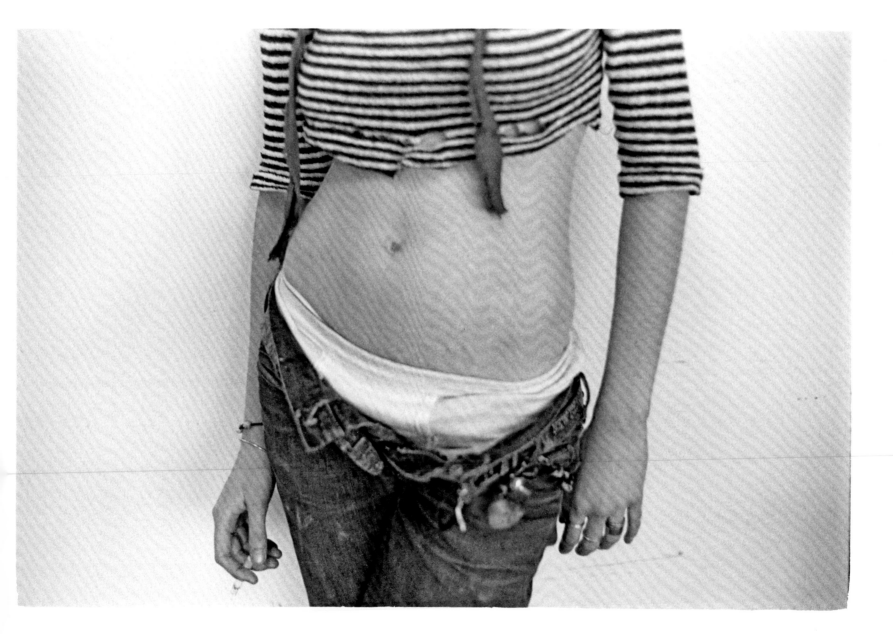

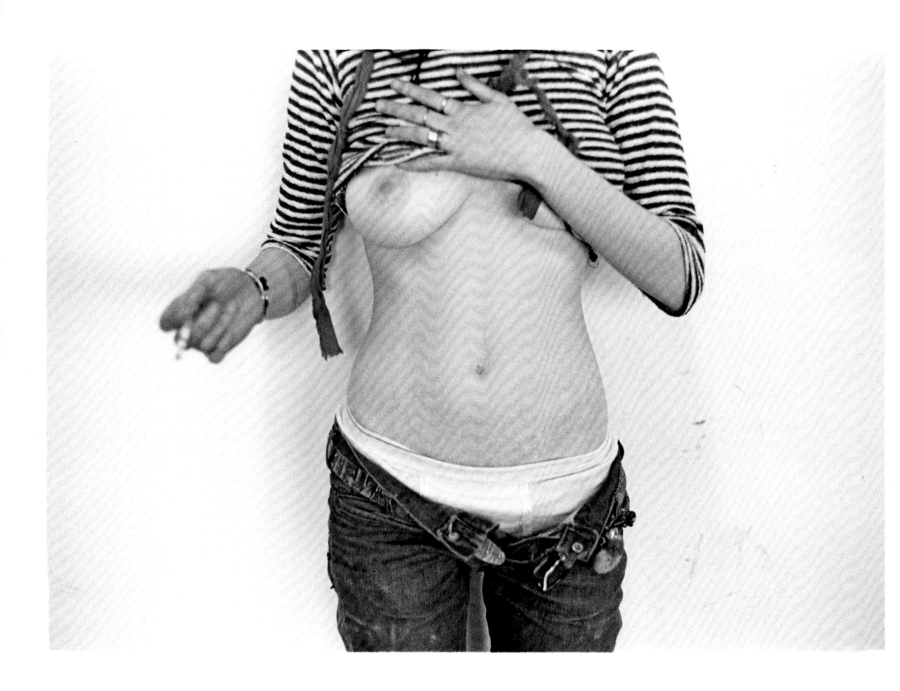

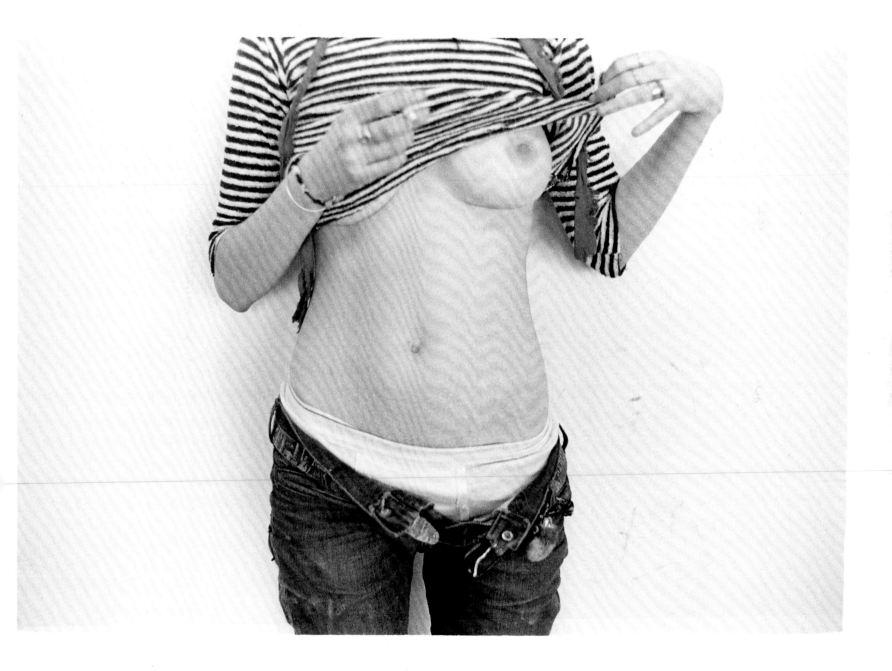

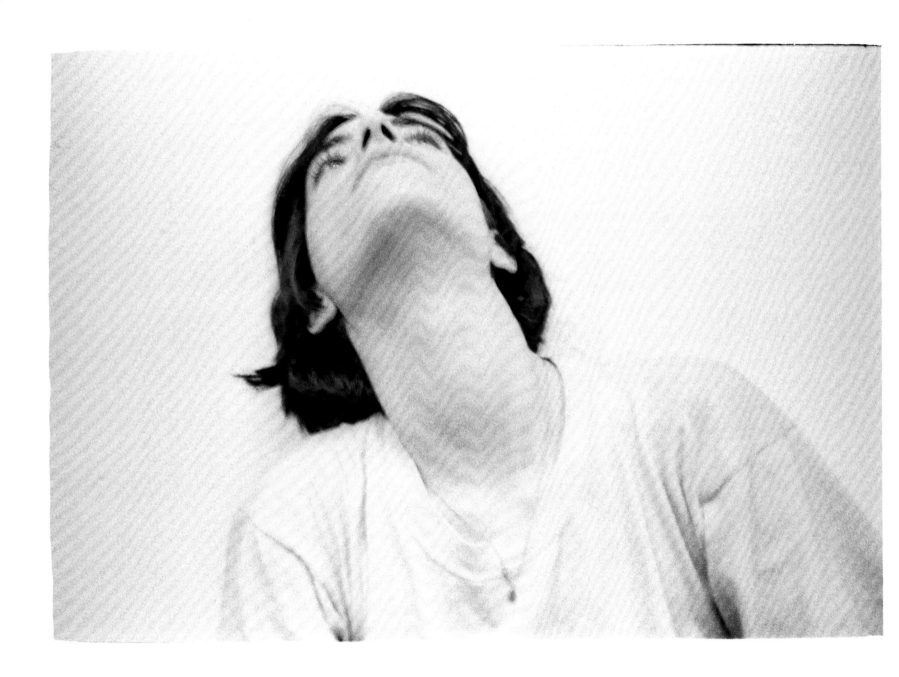

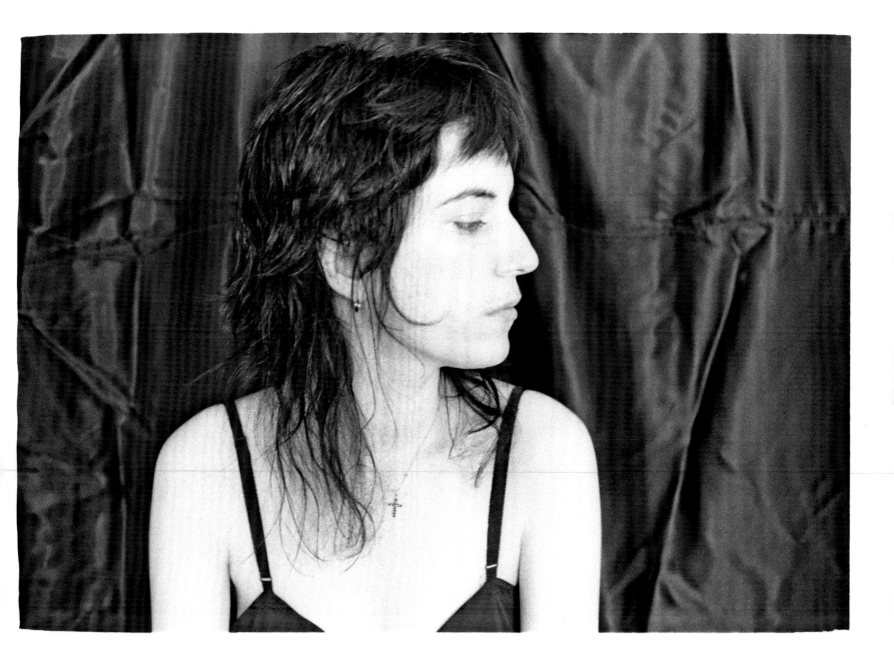

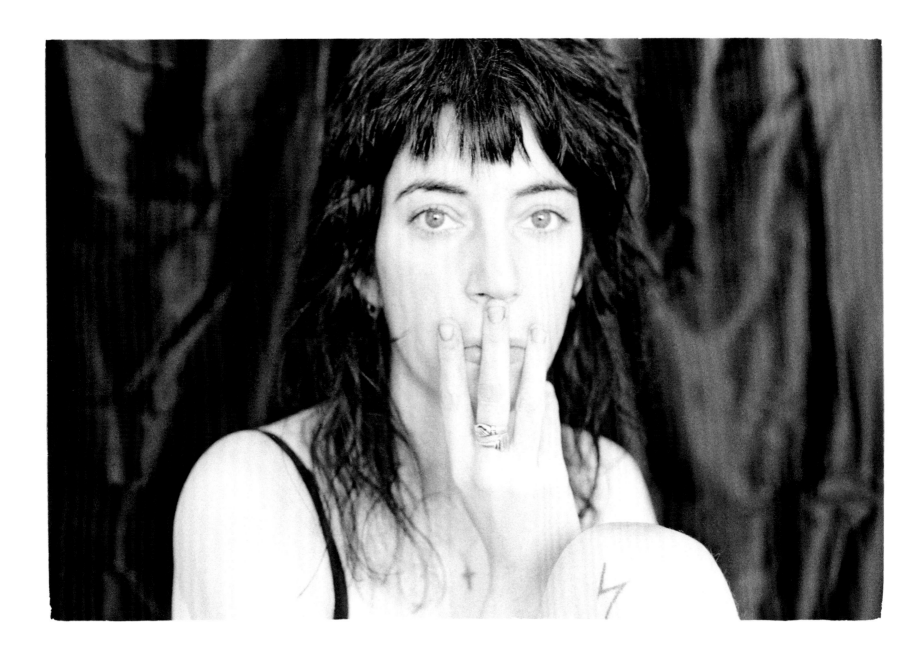

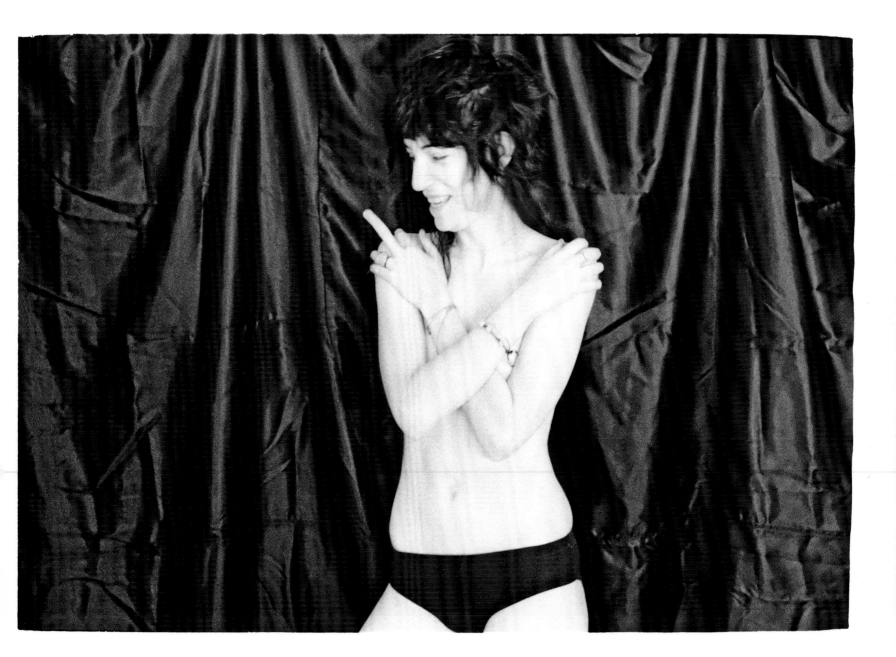

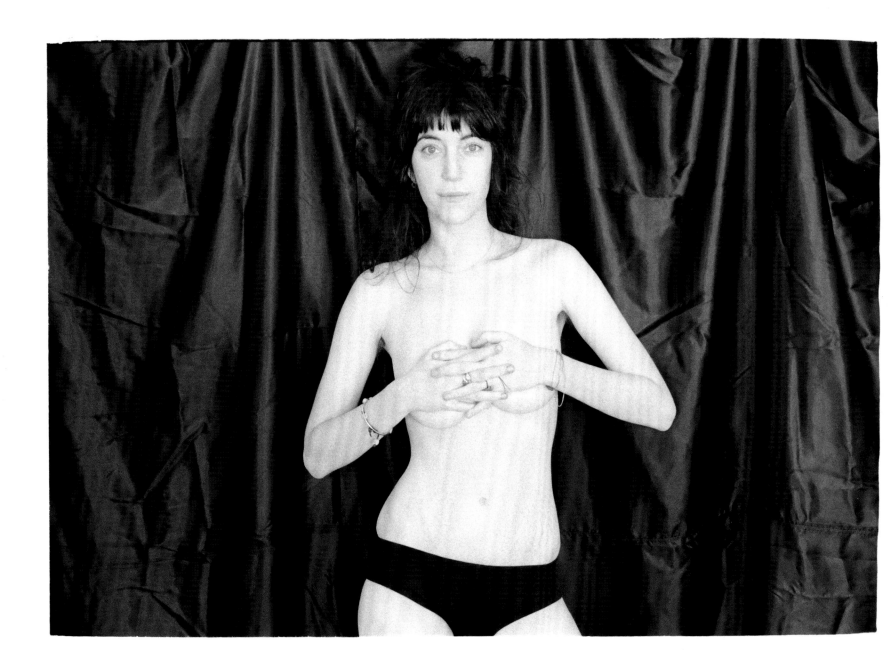

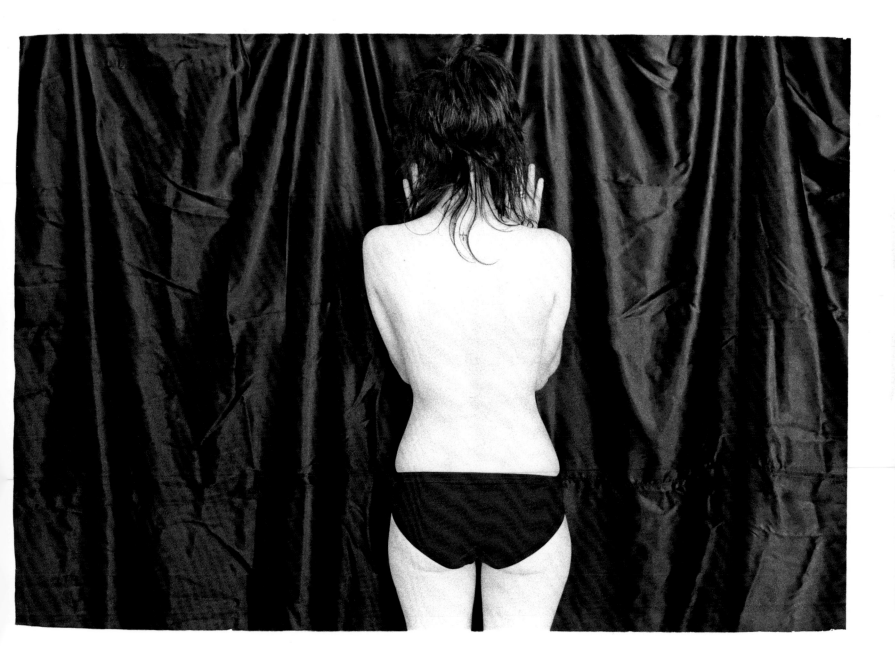

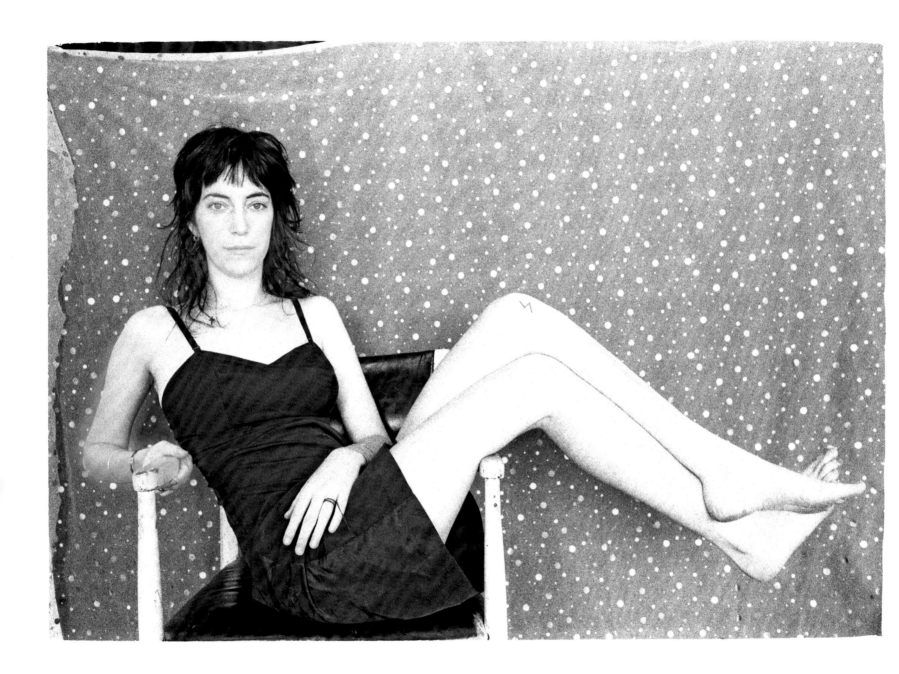

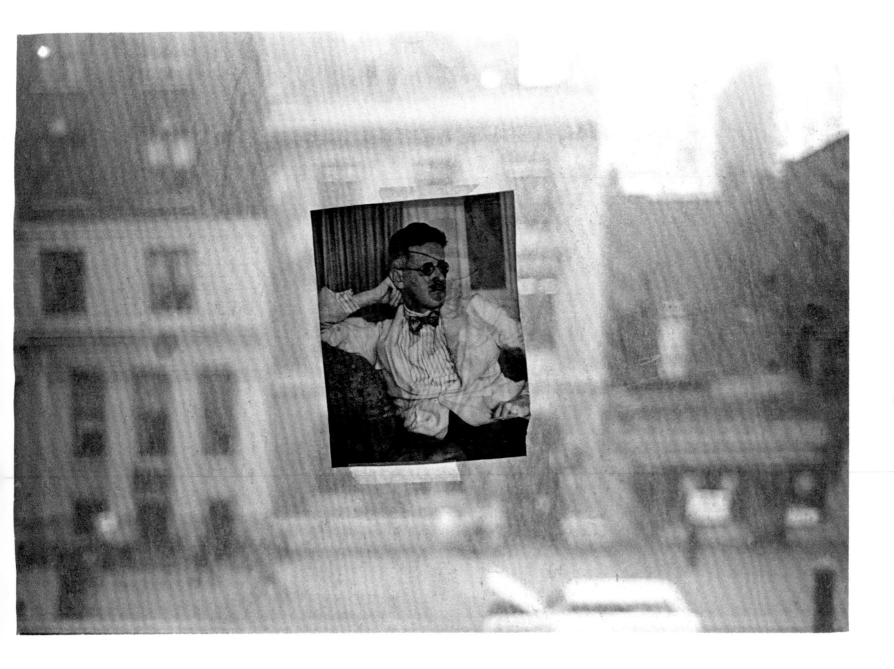

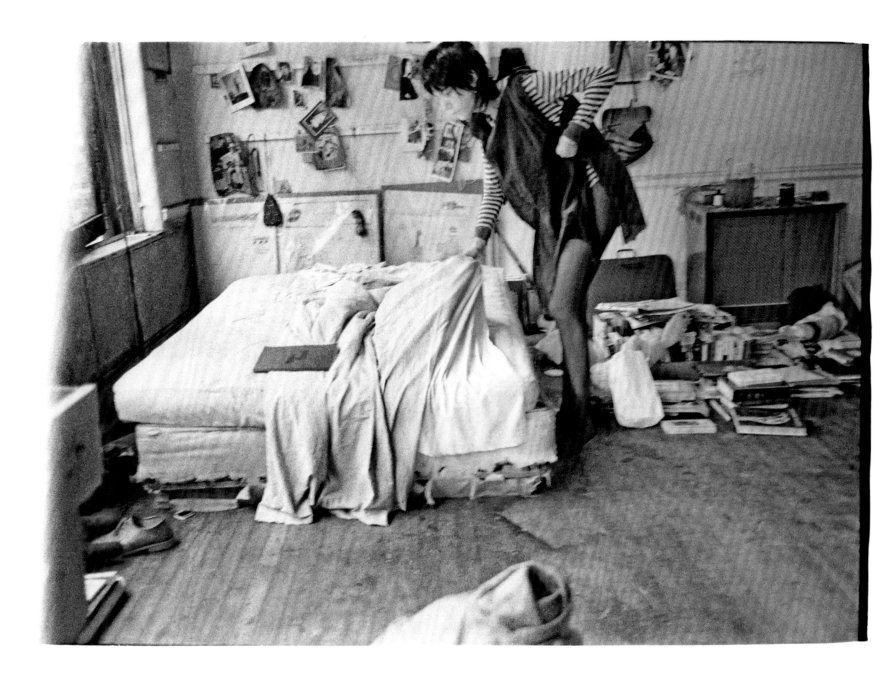

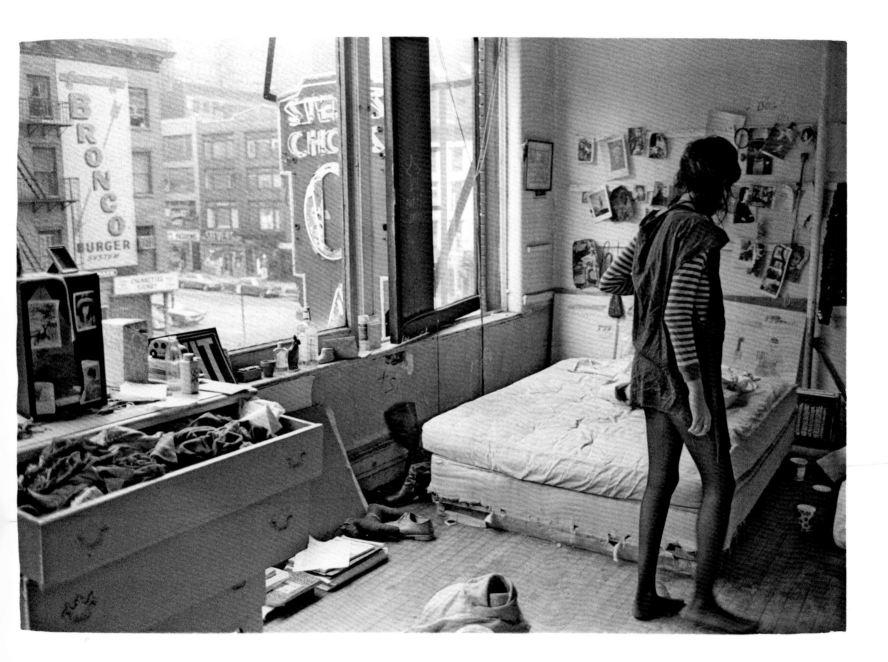

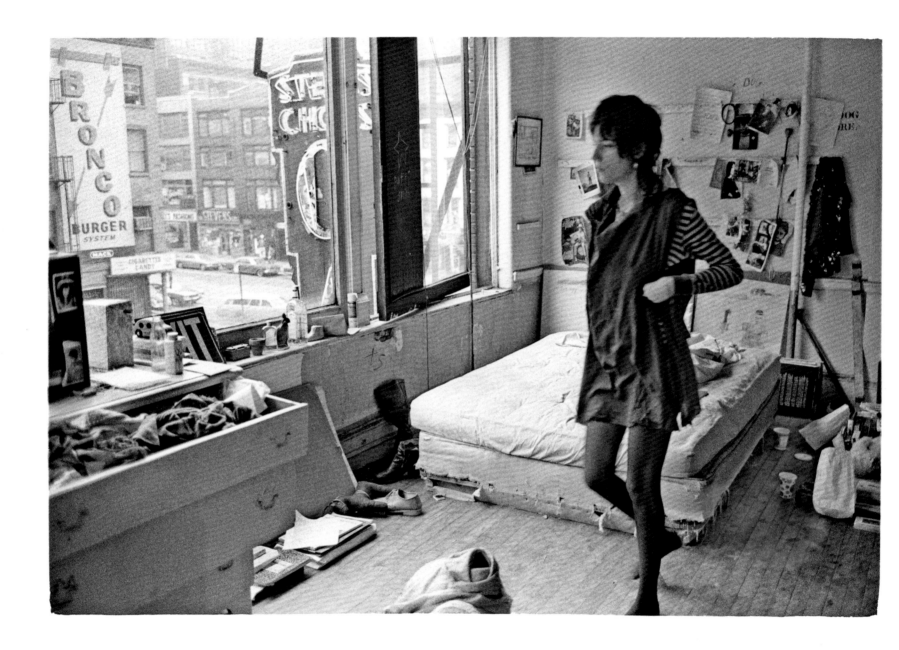

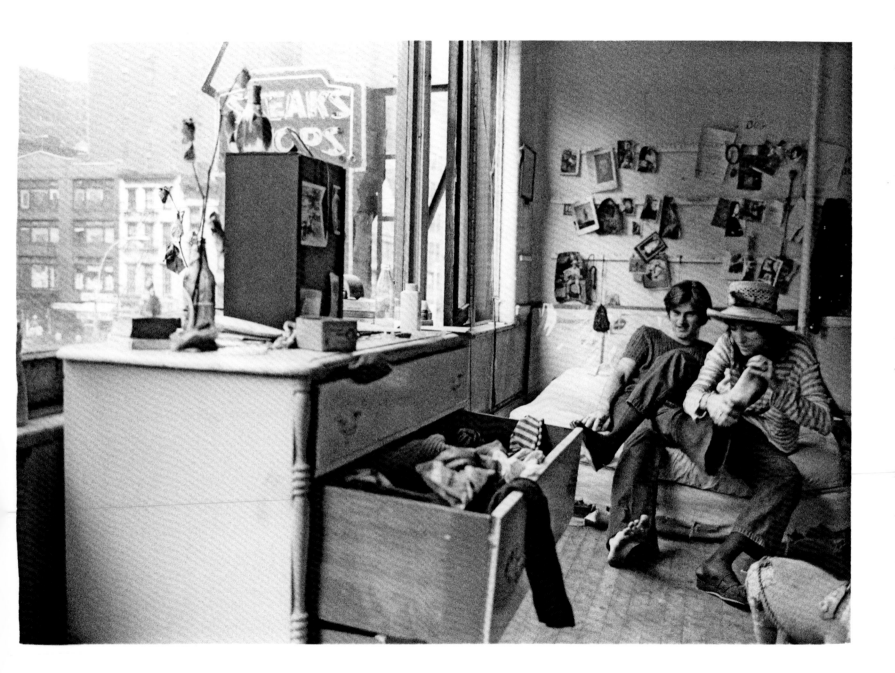

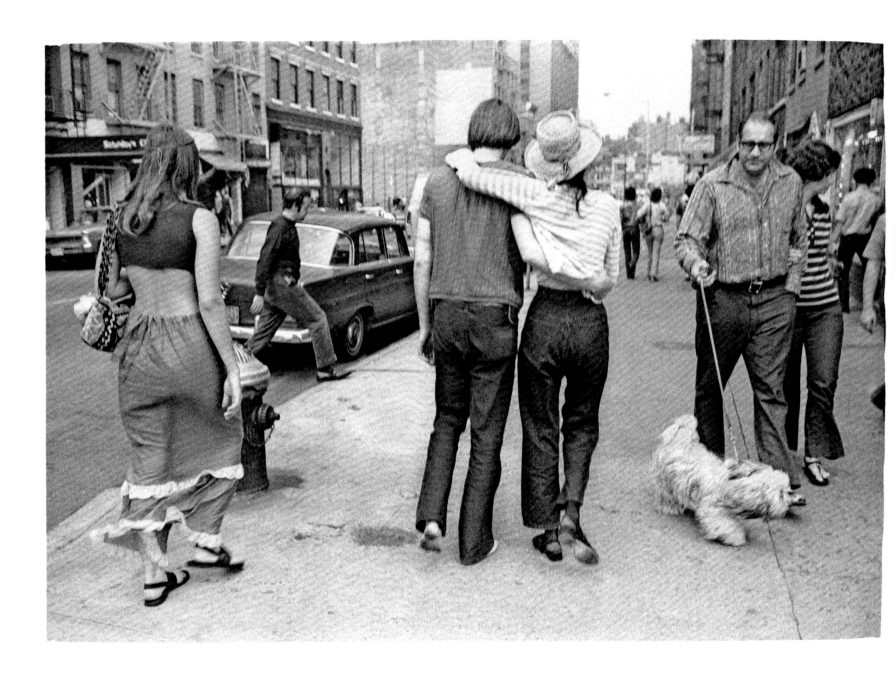

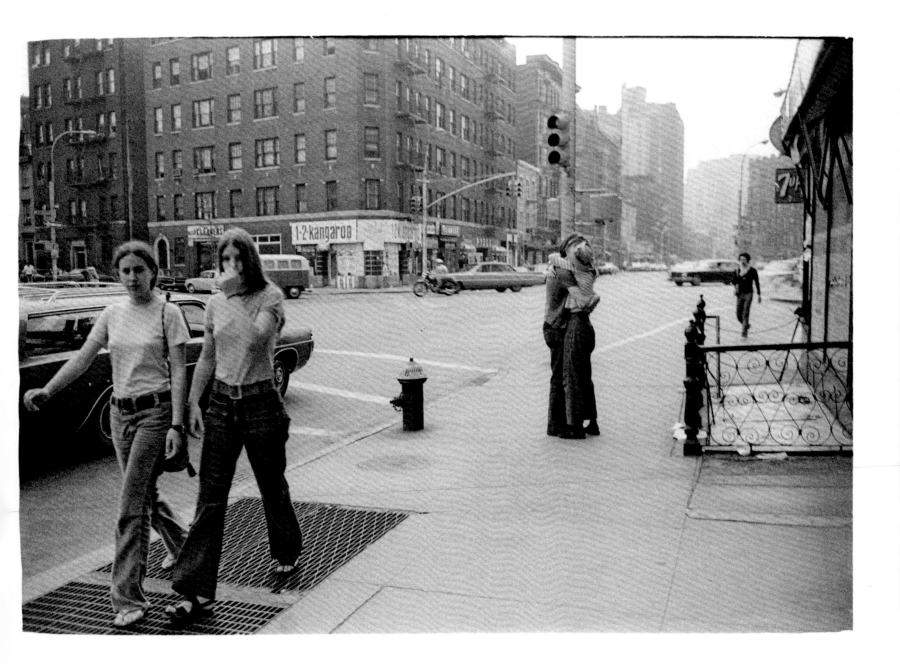

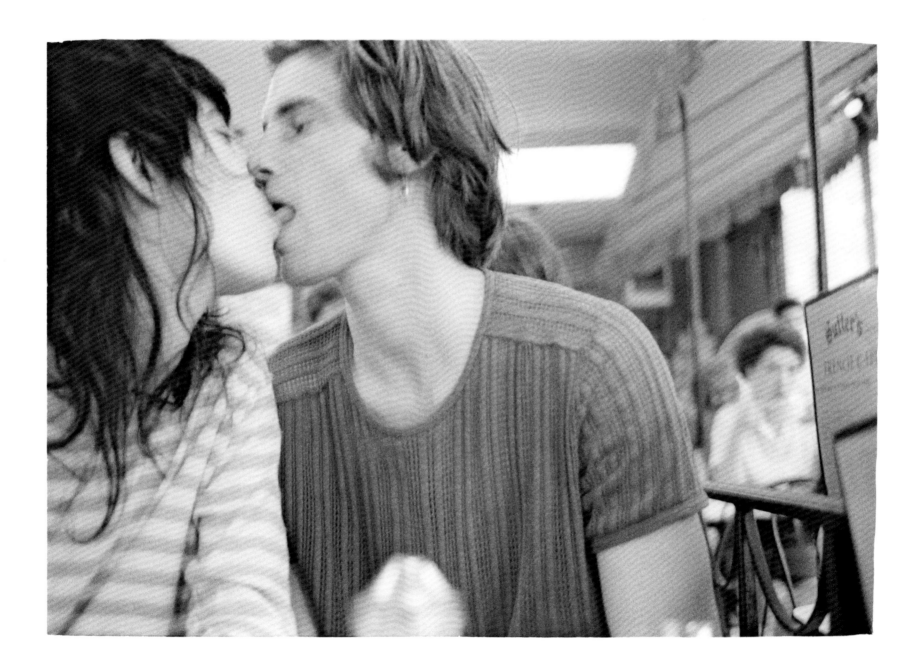

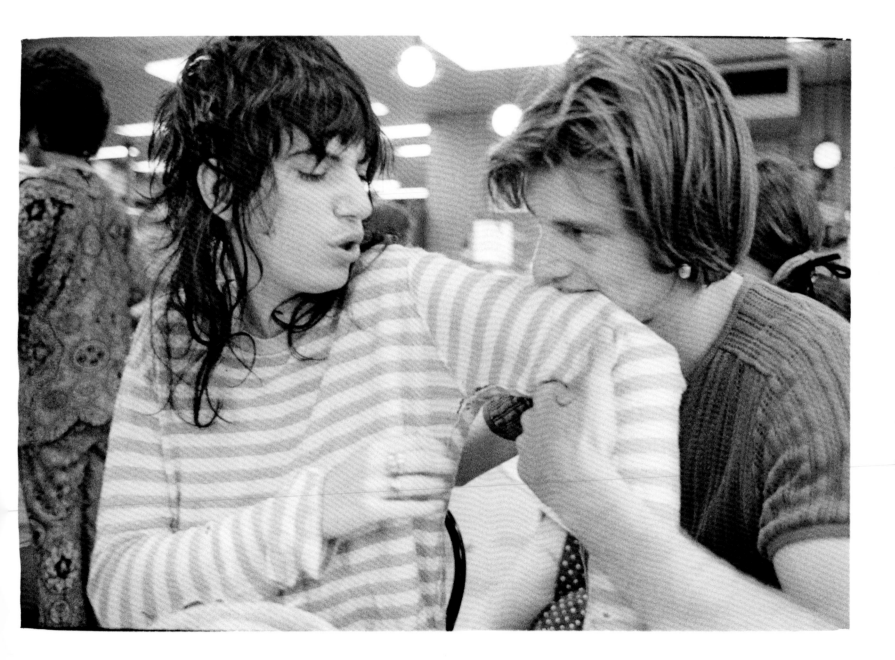

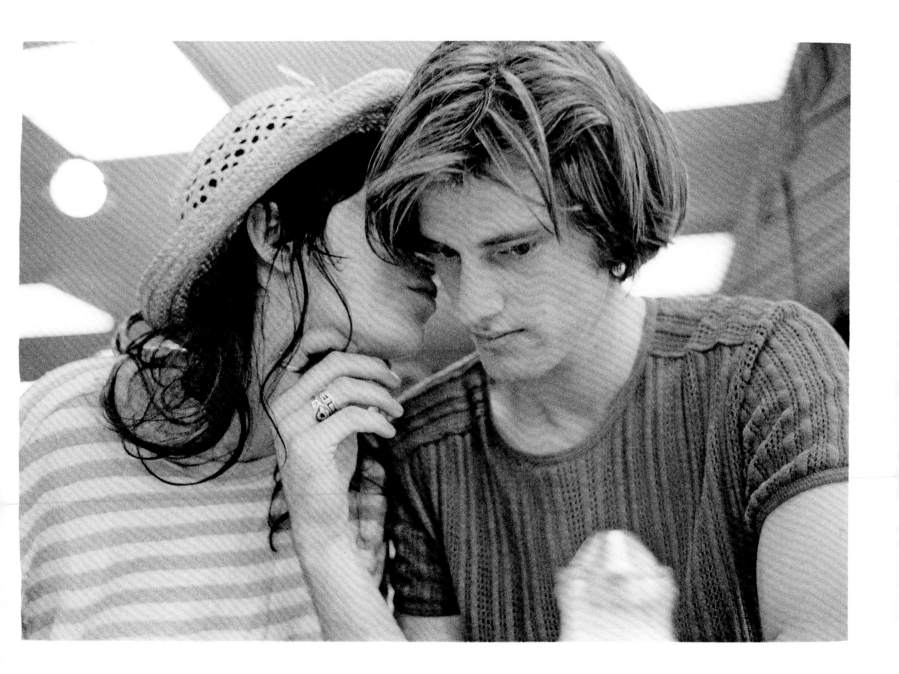

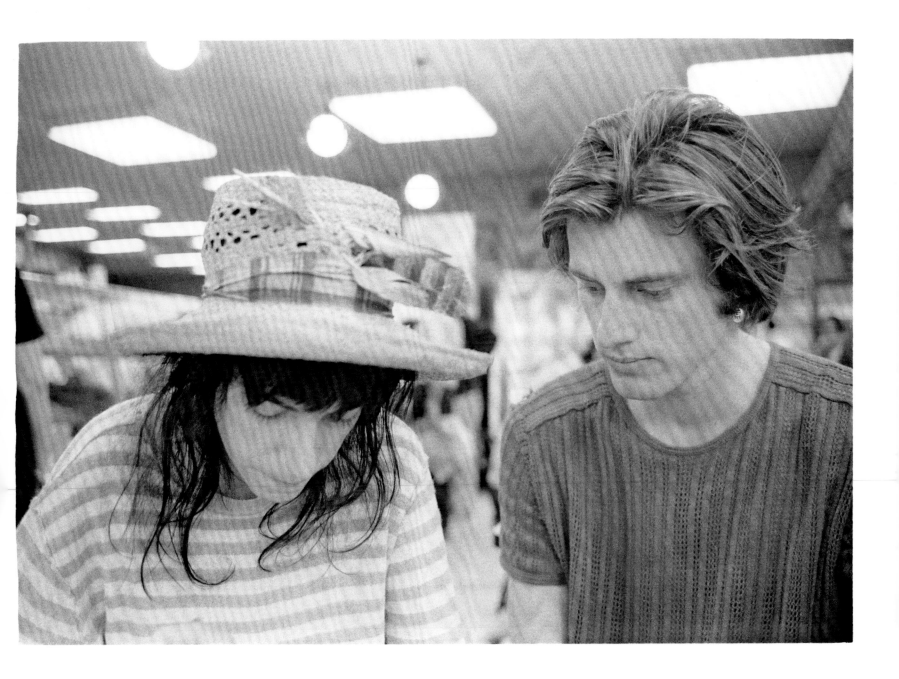

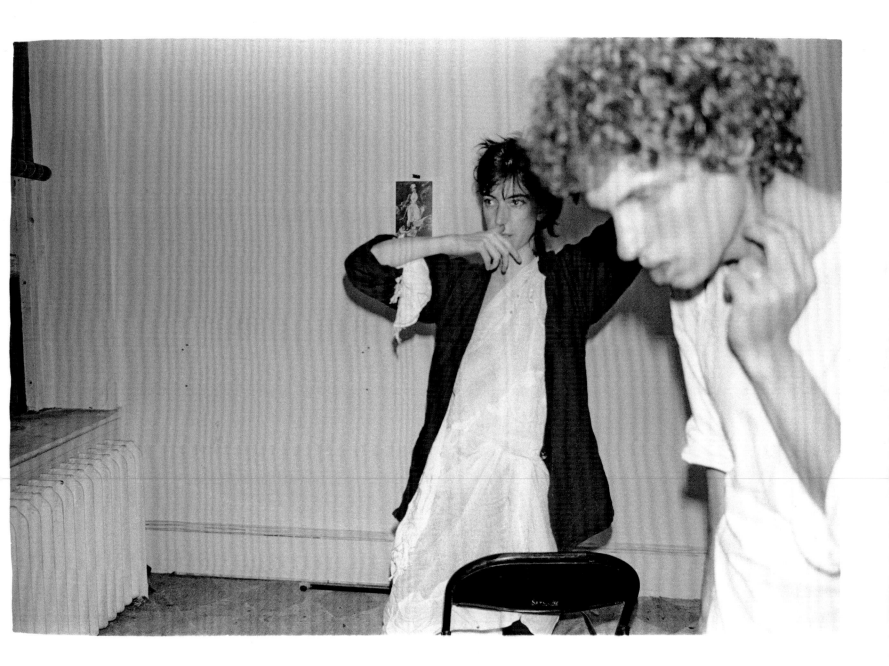

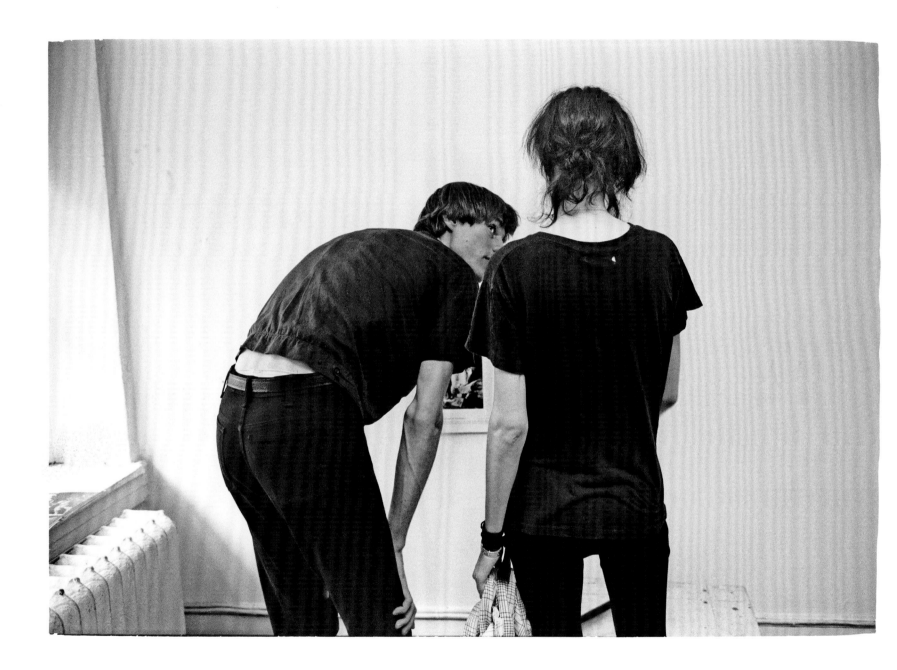

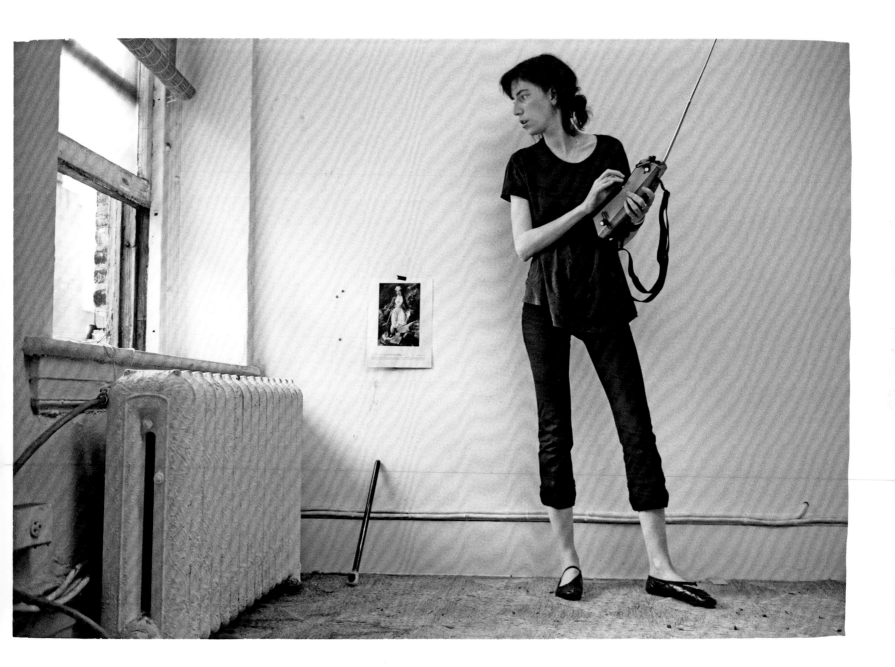

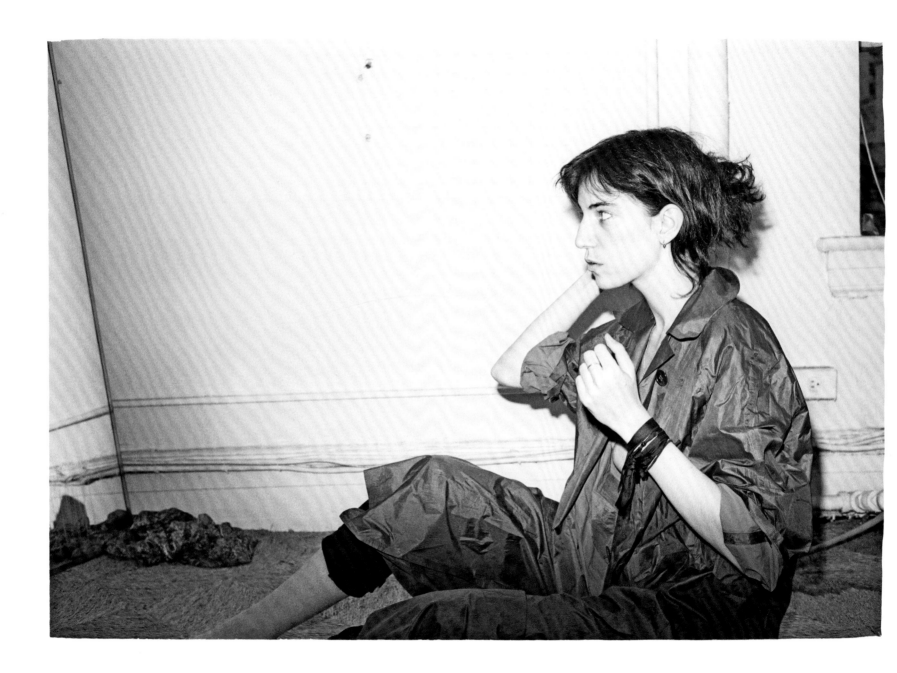

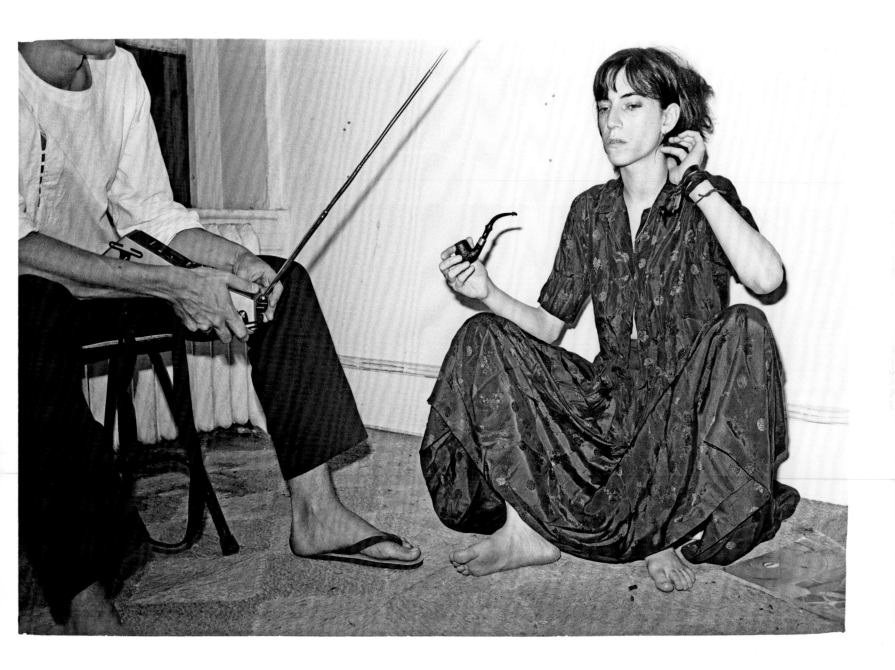

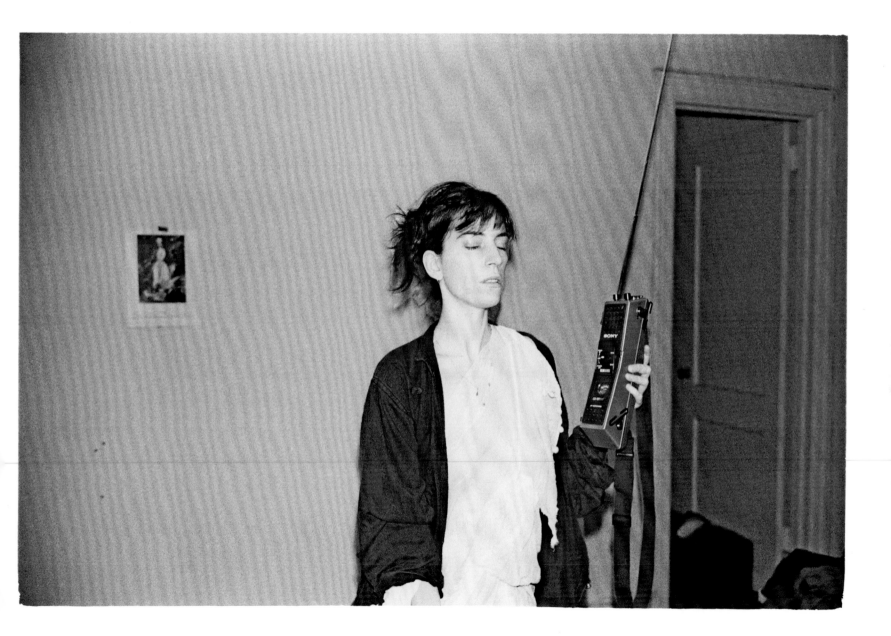

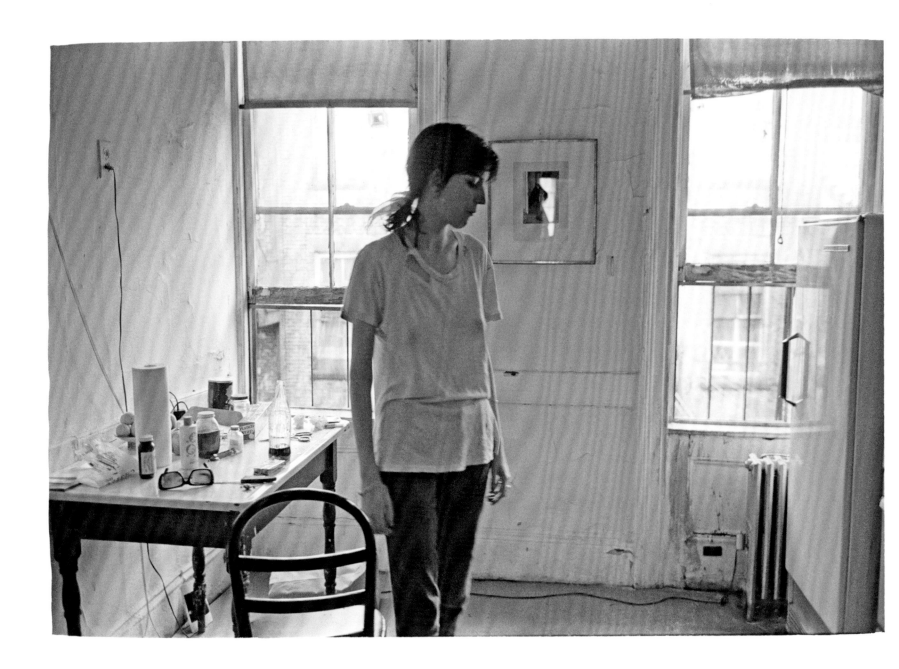

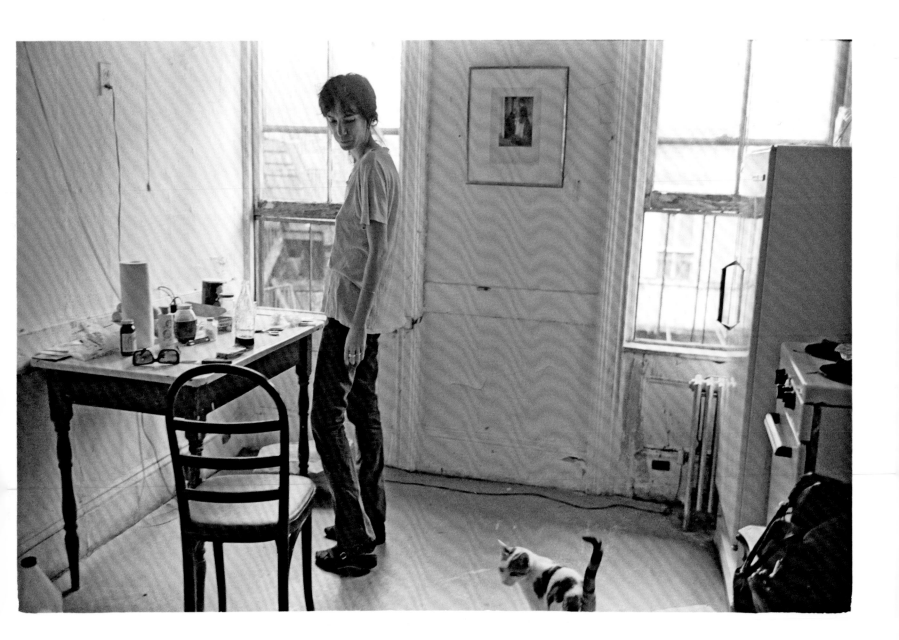

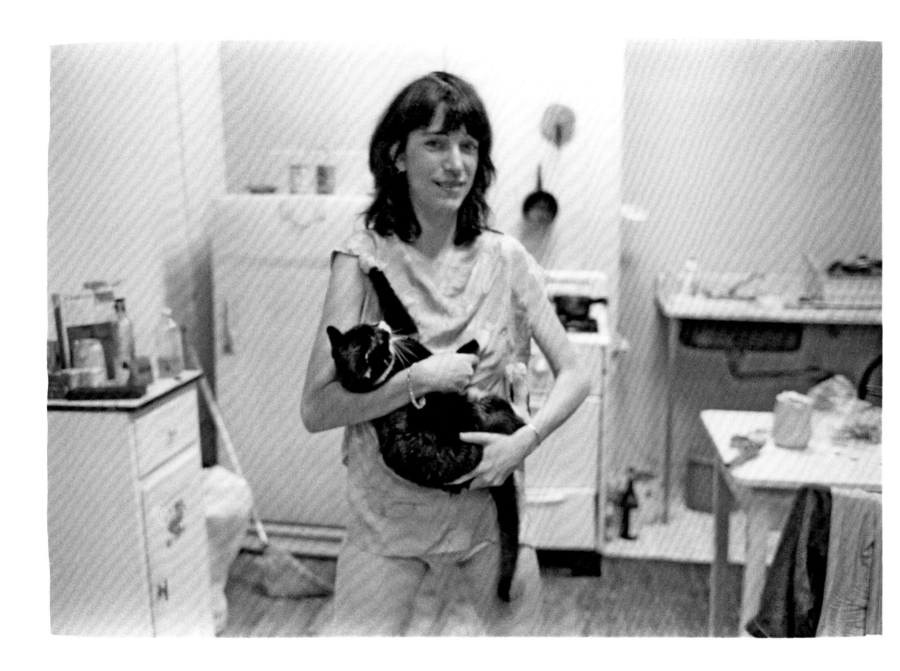

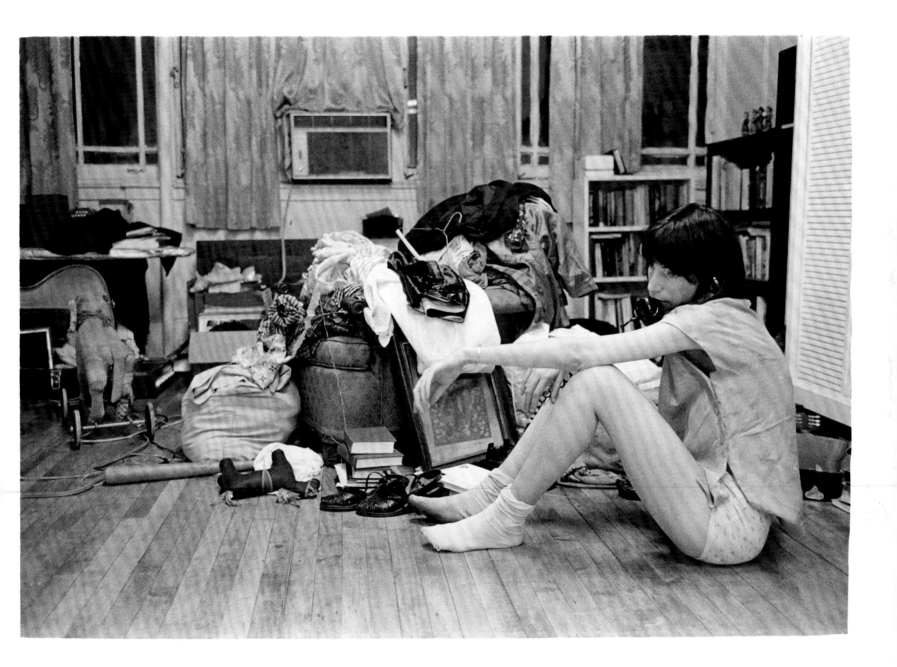

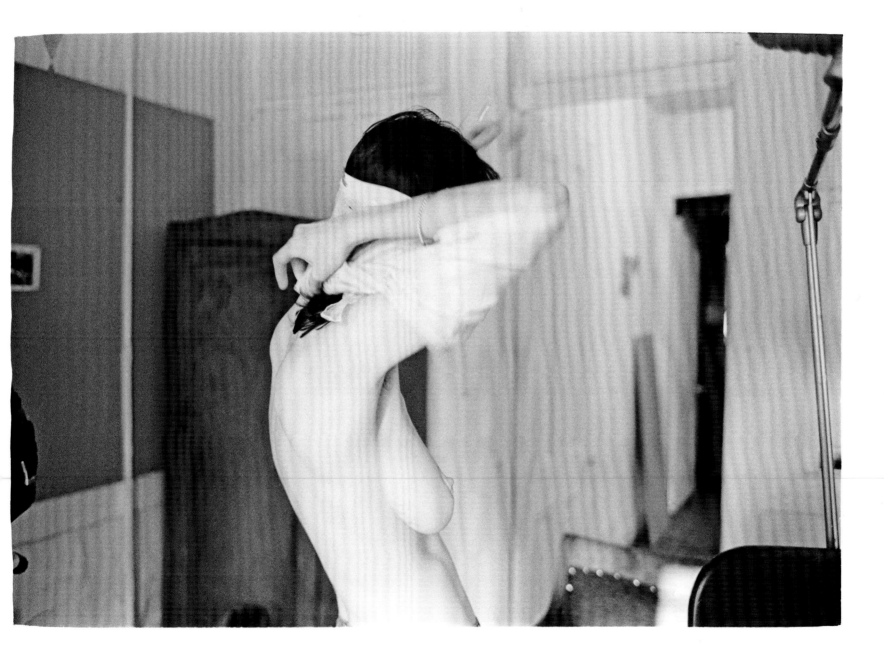

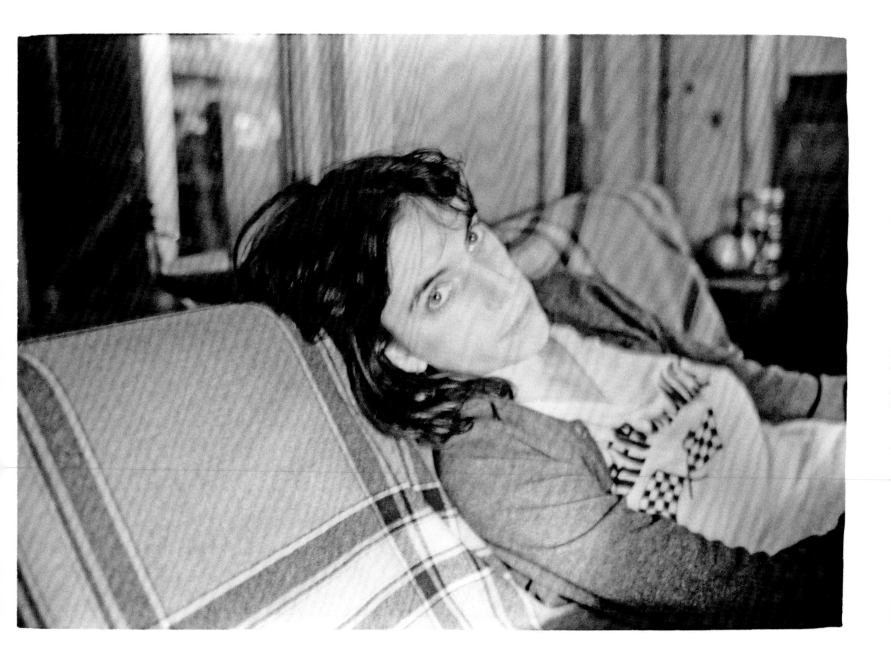

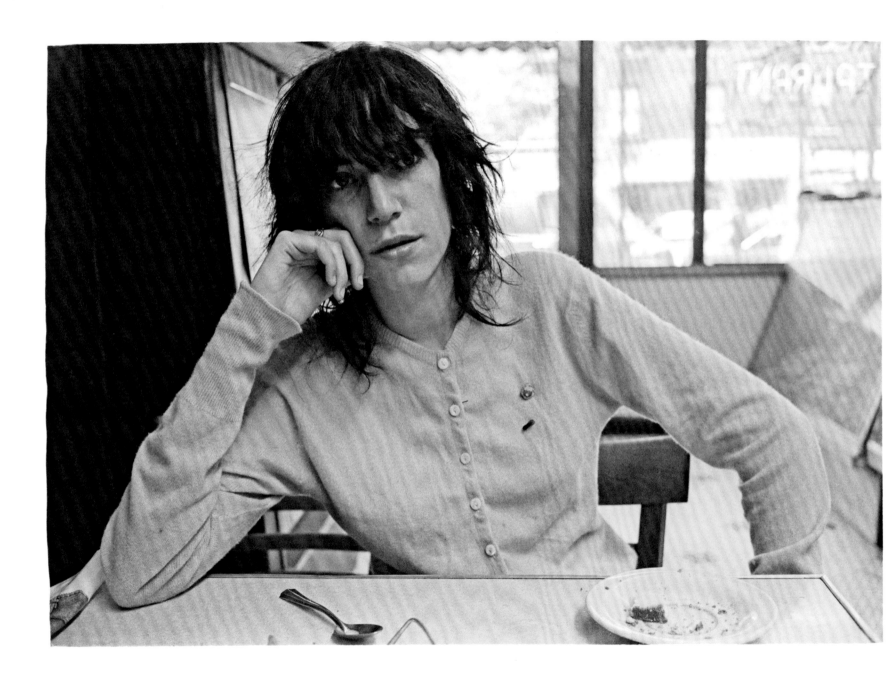

Index

Acknowledgments

Judy Linn would like to thank Hilton Als, Hendel Teicher, Hudson, Ferris Cook, Francine Prose, Denise Shannon, Jonathan Feld, Sam Rosenthal, Mona Kowalska, Daniel Feinberg, Kazuko Miyamoto, Jimi Dams, Gail Buckland, Susanne Hilberry, Nancy Linn, and Vassar College.

I took these photographs before I knew how.
In the beginning, it wasn't so much about who we were but who we wanted to be. Made without words or reason, they became an imaginary future. I can only remember the desire that created them—a private desire I learned from a childhood spent watching movies on TV. On a perfect Saturday afternoon, I did not read books, I did not go outside; I watched TV and drew.

Required to take photography in art school, I had a great teacher, Philip Perkis. He said there were brains in your eye. I became obsessed with taking photographs. How could it be that the work I was making was smarter than I was. There was a visual logic I never saw when I took the photograph, and each photograph had an illogical brilliance not of my making that was better than anything I could imagine. My own photographs were changing how I saw. In an attempt to comprehend this mystery, I took photographs of everything. And luckily, Patti liked to be photographed.

We met through our boyfriends, Peter Barnowsky and Robert Mapplethorpe. They were friends from the Pershing Rifles, a paramilitary gun-and-drill club that they must have quit when the Vietnam War dawned on them.

In the summer of '68, we became friends. At first Patti and I spent our afternoons drawing. When I started to photograph her, it seemed as easy as sharing colored pencils. It was simple. Patti liked to be photographed. Our photographs were as easy as the neatly drawn profiles of pretty girls found in a high school notebook. Devotedly complicit in our mutually constructed narrative, for me the photographs had been rehearsed by years of playing dress-up and acting out imaginary scenarios. If we liked a still of Anna Karina from a Godard movie, Patti and I could do a photograph, and it very well could have been from a Godard movie, if Jean-Luc had come to Brooklyn and looked us nobodies up. We were well prepared for a cinematic revelation. We worked at it because it was fun. Patti and I were friends the way children are friends. With chirpy little voices, we daydreamed a future.

Being female had always been a mystery to me, but it was also a secret source of inalienable content. It was unnoticed, untouched, and unmentioned in art school. Entering adolescence in an era of the Cold War nose-cone pointy bra and its copilot, the long-line girdle, required humor. Our female cosmology was delineated by the ever-present, easily available, greasy black Maybelline eye pencil.

That summer, Boston's Museum of Fine Arts' *Alfred Stieglitz: Photographer* became my primer. Looking at it every night, I thought I could memorize it and crack its grammar. The portraits of Georgia O'Keeffe had the pretentious goofiness of old postcard saints. I found Cecil Beaton's 1929 photographs of Nancy Cunard useful. There she sat in all her braceleted glory, in front of a crummy piece of polka-dot fabric stuck to the wall. I was inspired. I had masking tape.

In the mid-seventies my mentor in nascent photo lust was the collector Sam Wagstaff, Robert Mapplethorpe's boyfriend. Sam would buy you a good dinner and then take you home to show you his recently acquired photographs. A huge, ratty Claes Oldenburg doll hung from the ceiling amid piles of cardboard boxes, Sam's favorite mode of storage. He would have a stack of Gustave Le Gray photographs to get lost in or Adam Clark Vroman or Julia Margaret Cameron or Nadar or Frederick Evans or the family album of the last czar of Russia or Diane Arbus' children's fashion issue of the *New York Times Magazine* or a stereo daguerreotype and mahogany viewer of the giant lily pads at the Crystal Palace or stacks of Detroit Publishing postcards. He loved it all. Omnivorous and enthusiastic, he would proselytize for quality of any pedigree. A tall, handsome

connoisseur, I could never remember how old or how rich he was, or how many previous incarnations he had lived. He had squired debutantes, was part of the invasion force on Omaha Beach on D-day in World War II, had been in Madison Avenue advertising in the fifties, and had been an important museum curator of twentieth-century art in Detroit. When I first met Sam, he borrowed all my Stieglitz books. I was touched.

I found a cassette Patti and I made in '69. We were making a long-since lost 8mm movie in my tenement apartment in Brooklyn. I don't think I had listened to the cassette since we recorded it. On the tape, Patti recites a poem for the recently demised Brian Jones, and then I hear myself talking as we go off into the next room. Listening to the ambient sounds that came in through the open window, I realize it must have been a nice day. Waiting for us twenty-year-olds to come back into the room where the tape recorder is, I realize now that I am waiting for something that happened forty years ago.

Looking at these photographs, I never saw the time go by. Photographs let you hold the past in your hands, the imaginary past.

Judy Linn, 2010

From a Film Not Shot

I believe it was Robert who introduced me to Judy. She was with her boyfriend Peter, and I remember she was pretty and wore a summer skirt and a sleeveless blouse. I was taken with her intelligence and offbeat humor. She lived over a hardware store next to the laundromat on Myrtle Avenue beneath the train line. I did a lot of laundry, and we became friends with very little effort. I remember the word *friend* stenciled in colored pencil on a piece of newsprint. I think she gave it to me, but sometimes it seems as if I gave it to her.

We both loved black coffee, black slips, and black eyebrow pencil. We understood the impact of the right cashmere sweater, shantung capris, and a single string of pearls—even though we never wore them. Her aesthetic mirrored my own. We worshiped Robert Bresson and Albertine Sarrazin; we swooned over the jukebox scene in *Band of Outsiders*, the bird-head scene in *Judex*, and the trial of Falconetti as shot by Dreyer. In short, we lived for the movies, especially ones with subtitles.

When I was young, I often wondered if we were all players in some celestial film. I would pause to picture the existing moment as a still in this cinematic epic of life. As I grew, I gravitated toward films that possessed photographic beauty and dreamed of being a player in the grainy black-and-white world of the French New Wave. I also aspired to be an artist's model and studied the alliance between great artists and their muses—Victorine Meurent and Manet, Stieglitz and O'Keeffe, Anna Karina and Godard.

Judy shot with a Leica and was printing pictures that were like no one else's—tender and gritty. I still harbored a longing to model and once we got to know each other, it seemed only natural that I pose for her. I shared her strong feeling for photography, and we perused vintage fashion magazines for inspiration. I was eager to be Judy's model and to have the opportunity to work with a true artist. I felt protected in the atmosphere we created together. We had an inner narrative, producing our own unspoken film, with or without a camera.

Our lengthy preparations seemed as important as the results. The scene shot. The scene not. The long deliberation over the perfect raincoat, the lack of concern for my hairy legs—not a word about shaving. It was all part of our version of the feminine package. I did my best to carry off a slip and a cigarette though I was no Jeanne Moreau. As one who never wore a bathing suit, preferring an overcoat on the beach, I found myself

surprisingly at ease unclothed before her lens, like the blue angel in her camisole powdering her nose, with a sequined tux languishing over the dressing screen. We were two girls with no one to please. In time, I gathered more bravado. Judy's eye, impeccable. She photographed in series. She shot the spaces in between. In the end, what we got was ourselves.

Our male leads were the men of our world. A run of them. The painter Howard Michels—born with a caul, a veil-like membrane, over his face—who evoked the beauty of Brian Jones and the uneasiness of Jackson Pollock. Robert, as I remember him—confident, playful, and at times, unexpectedly pure. A solitary shot of his first boyfriend, Terry, at Fire Island. Terry's old boyfriend Fred. Robert combing his hair in our small room at the Chelsea Hotel. A glimpse of songwriter Matthew Reich, who loved Bob Dylan. The poet Gerard Malanga. The late Richard Sohl—my beloved pianist, with his ever-present flip-flops, as we set up for the cover of *Radio Ethiopia*. The back of Tom Verlaine.

Judy shot the hammer sequence at the Chelsea Hotel to help promote Robert's handmade jewelry. Robert's boyfriend David Croland and I modeled, never considering that there might be no real venue for the results. The work barely sold, but Judy's pictures remain a unique document of Robert's early jewelry, much of it since lost. I was not happy that day; the assignment took me out of the realm of our self-made film and I preferred being in our own world. I remember being moody as Robert put his arm around me. How I wish I could relive that moment now that he is gone.

The images that deeply touched me were those taken on Twenty-third Street, unseen until now. The setting was my half of the loft over the Oasis Bar that I shared with Robert. The scene of so many unmade beds. All my friends and mentors passed through this room that Robert had cleaned, painted, and made ready for me to live and work in. There are also moments shared with Sam Shepard. The two of us cut from the same flawed cloth. His magnetism. My restlessness. Two animals on the run, and the bit of peace we stole for a small while.

The way I was with Judy, I was with nobody else. We didn't fit in. But in our world the prom queen had nothing on us. We were girls playing dress up. I auditioned for our own movies, and I always got the part—Artaud in Mexico or a craggy Blaise Cendrars. Evolutionary leaps from the

innocence of a ponytail to the earliest projections as a rock-and-roll star—years before I crossed the imaginary line and actually became one. We often never got around to dressing for the part we wanted to play. We could easily be distracted by a hairclip or a hemline and then pack it in and go to Asia de Cuba for yellow rice and red beans.

Ever present within these images is our relationship as artist and model. The trust, the openness, the lack of guile between us. Our shared desire to invoke Juliette Gréco, a shy chorus girl, or the killer bee. All the facets of our envisioned selves set as the precious stones of youth.

I go back to the beginning when Judy and I met on a summer's day in 1968. Neither of our boyfriends, Peter nor Robert, survived the twentieth century. We never could have known we would outlive them, just as these photographs will outlive us all. But they both are here, embedded in our movie, the film not shot. And these are the stills. Like cards that fell from a mystical deck. Any way you shuffle them, they testify that once upon a time we were innocent and beautiful and anyone we imagined we could be.

Patti Smith, 2010

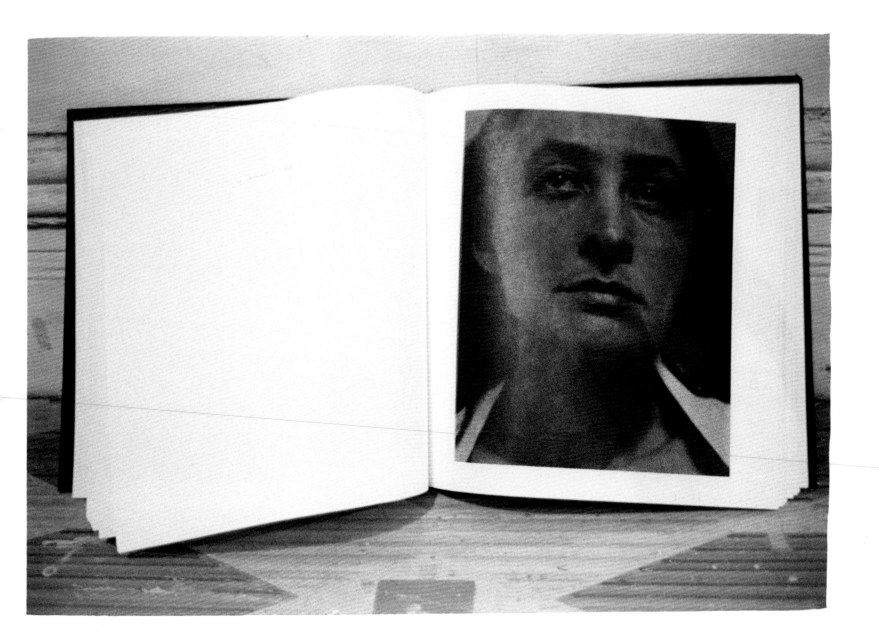

Editor: Tamar Brazis
Art Director: Michelle Ishay
Production Manager: Jacquie Poirier

Library of Congress Cataloging-in-Publication Data

Linn, Judy.
 Patti Smith, 1969–1976 / by Judy Linn ; afterword by Patti Smith.
 p. cm.
 Includes bibliographical references and index.
 ISBN 978-0-8109-9832-2 (alk. paper)
 1. Smith, Patti—Portraits. 2. Rock musicians—United States—Portraits.
I. Title.
 ML88.S753L56 2011
 782.42166092—dc22
 [B]

 2010050501
ISBN 978-0-8109-9832-2

Page 143: *Georgia O'Keeffe: A Portrait (6)*, 1918, photograph by Alfred Stieglitz. Published by MFA Publications,
a division of the Museum of Fine Arts, Boston. © 2010 Museum of Fine Arts, Boston. Reproduced by permission.

Printed and bound in Hong Kong, China
10 9 8 7 6 5 4 3 2

ABRAMS
THE ART OF BOOKS SINCE 1949
115 West 18th Street
New York, NY 10011
www.abramsbooks.com